This book illustrates the power and prevalence of the idea of grace – that is, the Protestant system of salvation – in Netherlandish art of the sixteenth and seventeenth centuries. It shows that artists were especially drawn to such subjects as the Return of the Prodigal Son and the Conversion of Paul, which served the Protestantism of the time as parables of salvation by grace alone, with no contribution by works or merit from weak and wayward man.

Professor Halewood points out that the implicit anti-humanism of this doctrine necessarily produced difficulties for artists trained in a humanist tradition, and that these difficulties were not resolved until Rembrandt invented a grace style. This approach to Rembrandt stresses his relation to the dominant religious attitudes of his time and country, emphasizing what was typical in his faith rather than his personal piety and spiritual insight.

WILLIAM H. HALEWOOD

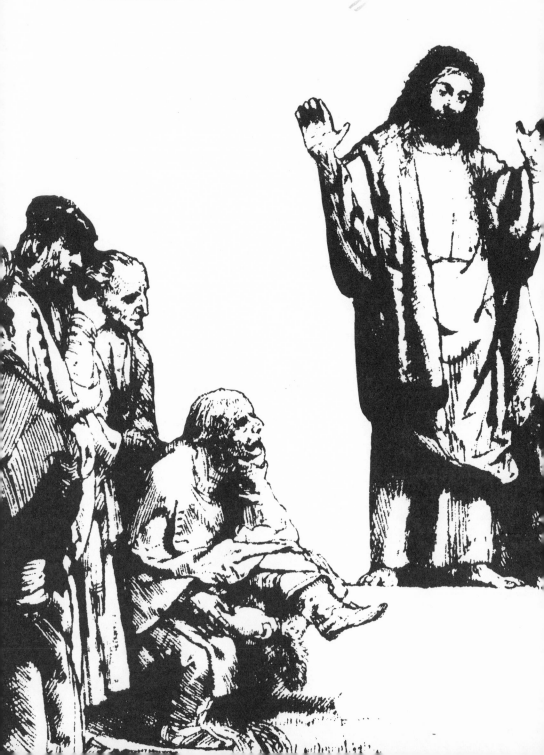

Six Subjects of Reformation Art: A Preface to Rembrandt

UNIVERSITY OF TORONTO PRESS
Toronto Buffalo London

© University of Toronto Press 1982
Toronto Buffalo London
Printed in Canada

ISBN 0-8020-2385-1 (cloth)
ISBN 0-8020-6491-4 (paper)

Canadian Cataloguing in Publication Data

Halewood, William H., 1929–
 Six subjects of Reformation art
 Includes index.
 ISBN 0-8020-2385-1 (bound) ISBN 0-8020-6491-4 (pbk.)
 1. Rembrandt, 1606–1669. 2. Reformation and art –
 Netherlands. 3. Art, Dutch. 4. Art, Modern –
 17th–18th centuries – Netherlands. I. Title.
 ND653.R4H34 704.948'2'09492 C81-094926-1

For Peter and Michael, Cindy and Sandy

Contents

PREFACE ix

ILLUSTRATIONS xi

1
Art and Reformation 4

2
Calling of Matthew 22

3
Raising of Lazarus 36

4
Prodigal Son 52

5
The Preaching of Jesus and John 66

6
Blessings and Healings 78

7
Conversion of Paul 108

8
Rembrandt: Three Crosses 124

NOTES 137

INDEX 151

Preface

THIS BOOK IS IN SEVERAL WAYS a blunter instrument than art history is used to, and in timid moments I have thought to take shelter in the claim that it is *sui generis*, simply a pictorial account of an idea. The idea is *grace*, or more particularly the Protestant paradigm of salvation, in which the saving of human souls is carried out entirely through God's active mercy (grace) with no contribution (no *works*, no *merit*) from weak and wayward man. The illustrations are a small selection of paintings, engravings, etchings, and drawings of a very large number of Netherlandish artists – not all avowed Protestants – whose works show that the idea of grace had power in their time. That its power produced contradiction and difficulty for artists trained in a humanist tradition is one of my repeated themes. That contradiction and difficulty cease with Rembrandt, who invents a grace style, is my hardest pressed conclusion.

The nature of the faith that informs Rembrandt's religious art has been much discussed, especially by persons (very often Protestant clergymen) concerned to stress the originality and penetration of his personal reading of the Bible. The present study differs in its attempt to locate Rembrandt in relation to the dominant religious attitudes of his time and place, emphasizing what was typical rather than individual in his faith. Its aim is rather to be suggestive than exhaustive. It is not the product of the kind of research that might establish clear connections between particular works of Rembrandt and reading that he may have done in particular tracts or commentaries, or sermons that he may have heard. My subject is the influence of a general tradition, though one with clear outlines. My point of view is secular, though it includes astonishment at the Reformation's astonishing proposition. Surely, grace *is* amazing, even (or perhaps most) to the most determined rationalist.

I am indebted to James Carscallen and Ralph Kaehler for scholarly kindnesses demanded in and out of season. Leonard Slotkes listened to parts of chapters 6 and 7, which were presented at the University of Chicago's Baroque Symposium in November 1978, and later read the entire manuscript, giving such counsels and cautions as I needed a true Rembrandtist to give. Giuseppe Scavizzi performed an essential service a good many years ago in leading me to the Decimal Index of the Art of the Low Countries. Ann Hiltie has been tireless in making the University of Toronto's somewhat dishevelled model of that splendid research instrument work for me. William Barker of the University of Toronto Press has done all that a learned and discerning editor could do, and our sessions have been a pleasure. The greatest of my debts is, as always, to my wife for every needful support.

Publication of this book is made possible by a grant from the Canadian Federation for the Humanities, using funds provided by the Social Sciences and Humanities Research Council of Canada, and a grant from the Publications Fund of the University of Toronto Press.

Illustrations

1 Michelangelo *The Last Judgment* Rome, Sistine Chapel

2 Michelangelo *The Last Judgment* Detail. Rome, Sistine Chapel

3 Michelangelo *The Last Judgment* Detail. Rome, Sistine Chapel

4 Michelangelo *Rondanini Pietà* Milan, Museo del Castello

5 Jan Sanders van Hemessen *Calling of Matthew* Munich, Alte Pinakothek

6 Caravaggio *Calling of St Matthew* Rome, Church of S Luigi del Francesci

7 Jan Sanders van Hemessen *Calling of Matthew* New York, Metropolitan Museum of Art

8 Jacob van Oost *Calling of St Matthew* Bruges, Church of Our Lady

9 Arnold Houbraken *Calling of Matthew* Drawing. Leipzig, Museum der bildenden Kunst

10 Jan Pynas *The Calling of Matthew* Dessau, Gemäldegälerie

11 Nicolaes Moeyaert *Calling of Matthew* Drawing. Windsor Castle

12 Lucas Cranach the Elder *Raising of Lazarus* Nordhausen, Blasiuskirche

13 Peter Aertsen *Christ with Mary and Martha* Brussels, Palais des Beaux-Arts

14 Marten de Vos *Raising of Lazarus* Munich, Alte Pinakothek

15 Jan Pynas *Raising of Lazarus* Munich, Alte Pinakothek

16 Rembrandt *Raising of Lazarus* Drawing. London. British Museum (Benesch 17)

17 Jan Lievens *Raising of Lazarus* Etching, third state

18 Rembrandt *Raising of Lazarus* Los Angeles, Los Angeles County Museum of Art (Br 538)

19 Rembrandt *Raising of Lazarus* Etching (B 73)

20 Rembrandt *Raising of Lazarus* Etching (B 72)

21 Hans Bol *Return of the Prodigal Son* Drawing. Vienna, Albertina

21 Jan Steen *Return of the Prodigal Son* Collection Countess Brita Wachtmeister, Gunnarstorp, Sweden

23 Cornelis Massys *Return of the Prodigal Son* Amsterdam, Rijksmuseum

24 Peter Lastman *Return of the Prodigal Son* Oxford, Ashmolean Museum

25 Rembrandt *Return of the Prodigal Son* Etching (B 91)

26 Maerten van Heemskerck *Return of the Prodigal Son* Woodcut

27 Maerten van Heemskerck *Return of the Prodigal Son* Engraving by Philip Galle

28 Rembrandt *Return of the Prodigal Son* Leningrad, Hermitage (Br 598)

29 Rembrandt *Departure of Tobias* Drawing. Paris, Fondation Custodia,
Coll. F. Lugt (Benesch 1264 as *Return of the Prodigal Son*)

30 Adriaen van Stalbent *John Preaching* Munich, Alte Pinakothek (Formerly
attributed to Adam Elsheimer)

31 Peter Brueghel *John Preaching* Budapest, Museum of Fine Arts

32 E. van de Velde *Christ Preaching from a Ship* Drawing. Amsterdam, Rijksmuseum

33 Herri met de Bles *St John the Baptist Preaching* Belgium, Private Collection

34 Jan Brueghel the elder *Christ Preaching* Belgium, Private Collection

35 Rembrandt *Christ Preaching the Remission of Sins* Etching (B 67)

36 Rembrandt *Preaching of St John the Baptist* Berlin, Gemäldegalerie, Staatliche
Museen Preussicher Kulturbesitz

37 J. Collaert after a drawing by Maerten de Vos *Remissionem Peccatorum* Engraving

38 Nicolaes Maes *Christ Blessing the Children* London. National Gallery

39 Samuel van Hoogstraten *Christ Blessing the Children* Drawing. Hamburg,
Kunsthalle

40 Jacob de Wet *Christ Blessing the Children* London, 1951 sale catalogue
(as by G. van Eckhout)

41 Hieronymus Francken the Elder *Christ Blessing the Children* Lucerne,
1947 sale catalogue

42 Werner van den Valckert *Christ Blessing the Children* Utrecht, Rijksmuseum

43 Vincent Sellaert *Christ Blessing the Children* Munich, Alte Pinakothek

44 Cornelis Cornelisz. *Christ Blessing the Children* Haarlem, Frans Halsmuseum

45 Adam van Noort *Christ Blessing the Children* Mainz, Mittelrheinisches
Landesmuseum

46 Jacob Jordaens *Christ Blessing the Children* Copenhagen, Nationalmuseum

47 Attributed to Jacob Jordaens *Christ Blessing the Children* Drawing. Besançon,
Musée

48 Master of the Gathering of the Manna. *Christ Healing the Blind Man* Blaricum,
The Netherlands. Coll. Prof. P. J. Kleiweg de Zwaan. On loan to Museum
Mr. Simon van Gijn, Dordrecht

49 Hans von Aachen *Resuscitation of the Young Man of Nain* Munich,
Alte Pinakothek

50 David Vinckeboons *The Centurion of Capernaum Asks Christ to Heal His Servant* Berlin, 1942 Sale Catalogue

51 Lucas van Uden *Christ and the Centurion of Capernaum* Munich, 1929 Sale Catalogue

52 Jacob Jordaens *Christ Healing the Sick* Drawing. Leningrad, Hermitage

53 Rembrandt *Baptism of the Ethiopian Eunuch* Etching (B 98)

54 Maerten van Heemskerck *Baptism of the Ethiopian Eunuch* Engraving by Philip Galle

55 Rembrandt *Peter and John Healing the Cripple at the Gate of the Temple* Etching (B 94)

56 Rembrandt *Isaac Blessing Jacob* Drawing. Angers, Musée (Benesch 510)

57 Rembrandt *Jacob Blessing the Children of Joseph* Cassel, Gemäldegalerie (Br 525)

58 Guercino *Jacob Blessing the Sons of Joseph* Lost (1945)

59 Rembrandt *The Reconciliation of David and Absalom* Leningrad, Hermitage (Br 511)

60 Rembrandt *Raguel Welcomes Tobias* Drawing. Amsterdam, Rijksmuseum (Benesch 871)

61 Rembrandt *Jacob Wrestling with the Angel* Berlin, Gemäldegalerie, Staatliche Museen Preussicher Kulturbesitz (Br 528)

62 Rembrandt *The Sacrifice of Abraham* Etching (B 35)

63 Rembrandt *The Angel Stopping Abraham from Sacrificing Isaac* Leningrad, Hermitage (Br 498)

64 Lucas van Leyden *Conversion of St Paul* Engraving

65 Maerten van Heemskerck *Conversion of Paul* Engraving by P. Galle

66 Benjamin Gerritsz. Cuyp *Conversion of Saul* Vienna, Gemäldegalerie

67 Aelbert Cuyp *Conversion of Paul* London, 1964 sale catalogue

68 Karel Dujardin *Conversion of Paul*. London, National Gallery

69 Caravaggio *Conversion of St Paul* Rome, Chiesa di S Maria del Popolo

70 N. Beatrizet *Conversion of St Paul* Engraving after Michelangelo

71 Rembrandt *Conversion of Paul* Drawing. Berlin, Berlin Kupferstichkabinett. Staatliche Museen Preussischer Kulturbesitz (Benesch 178)

72 Rembrandt *Entombment* Drawing. Berlin, Berlin Kupferstichkabinett, Staatliche Museen Preussischer Kulturbesitz (Benesch 1209)

73 Rembrandt *The Apostle Paul at His Desk* Washington, National Gallery of Art (Br 612)

74 Rembrandt *Self-Portrait as the Apostle Paul* Amsterdam, Rijksmuseum

75 Rembrandt *Jesus Healing the Sick* ('The Hundred Guilder Print') Etching (B 74)

76 Rembrandt *The Three Crosses* Etching, First State (B 78)

77 Rembrandt *The Three Crosses* Etching, Fourth state (B 78)
78 Rembrandt *The Apostle Peter Denying Christ* Amsterdam, Rijksmuseum (Br 594)
79 Rembrandt *David Playing the Harp Before Saul* The Hague, Mauritshuis (Br 526)

PHOTOGRAPHIC CREDITS

My thanks are due to the museums and private collectors for permitting the reproduction of paintings, drawings, and prints in their collections. Figure 11 is reproduced with the gracious permission of Her Majesty Queen Elizabeth II. Most of the photographs have been supplied by the owners or custodians of the works of art. Other suppliers are the following, whose courtesy is gratefully acknowledged: Alinari (figures 1, 2, 4, 6, 69); Institut Royal du Patrimoine Artistique, Brussels (figures 8 and 13); Hans Peterson, Copenhagen (figure 46); Fondation Custodia (Collection F. Lugt), Institut Néerlandais, Paris (figure 29); John R. Freeman, London (figure 37); Lichtbildwerkstätte 'Alpenland' Vienna (figure 21); Photoatelier Jörg P. Anders, Berlin (figures 37, 61, 72). Photographs of etchings and engravings in their own collections have been provided by the Amsterdam Printroom (figures 17, 19, 20, 25, 26, 27, 35, 53, 55, 57, 75, 76, 77), the Print Cabinet of the University of Leiden (figures 64, 65, 70), and the Department of Prints and Drawings of the British Museum, London (figure 35).

SIX SUBJECTS OF REFORMATION ART:

A PREFACE TO REMBRANDT

1: Art and Reformation

FOR VARIOUS REASONS, art history has not given an adequate account of the influence of the Protestant Reformation on the practice of artists in the sixteenth and seventeenth centuries. One problem has been a tendency to leave religious ideas to religious practitioners. Another has been reluctance to deal with the obvious: there is 'nothing original,' according to a leading specialist in the field, in arguing a 'causal relationship ... between Protestantism and seventeenth-century painting. Most of us take it for granted.'[1] Still, there has been no unanimity, and efforts to come to terms with the whole question have tended to be both piecemeal and contradictory.[2] Thus, according to a common opinion, Rembrandt was the only major artist to find inspiration in Protestantism: 'Rembrandt is ... exceptional, almost unique in giving expression to Protestant piety.'[3] But it is equally common to recognize that Cranach, Dürer, and Holbein also give expression to Protestant piety, and even painters as remote from the centres of Protestant Europe as Michelangelo and Caravaggio have been shown to be touched, however indirectly, by Reformation teaching.[4]

All claims for positive influences of the Reformation are of course contradicted by the widely held and justifiable notion that early Protestantism was merely negative in its dealings with the arts.[5] Calvin had discouraged religious art with the argument that images were really not distinguishable from idols. Zwingli had driven the arts, including music, out of the church in Zürich.[6] And rougher followers of the Reformation committed such notable acts of hostility to the arts as the 'Great Idolomachy' of Basel in 1529, in which statues of saints were smashed and paintings destroyed. Other events of the kind occured all over Reformation Europe, sometimes, as in England, with the encouragement of official government policy. Indeed, perhaps the most interesting iconoclast document of the two centuries is William Dowsing's diary of 1643–4 in which a 'Parliamentary Visitor' made such (possibly exaggerated) day-by-day notations as the following:

Stoke-Nayland, Jan. the 19th. We brake down an 100 superstitious pictures; and took up 7 superstitious Inscriptions on the Grave-Stones, *ora pro nobis*, &c.
Barham, Jan. the 22nd. We brake down the 12 Apostles in the Chancel, and 6 superstitious more there; and 8 in the Church, one a Lamb with a Cross X on the back; and digged down the [altar] Steps ...[7]

Erasmus deplored the 'odious fury' of early iconoclasts, whose violence, however, simply expressed in action a settled prejudice of early Protestant-

ism. Conditions must have been, at best, puzzling for artists attempting to work in Protestant countries. In some locations, Zürich being a notable example, the arts virtually died out. In others, artists abandoned religious subjects and devoted themselves to the safely neutral fields of portrait, landscape, genre, still life, and classical mythology and history.

If this redirection had been universal the story of the Reformation's impact on the arts would of course be easy enough to tell. But, despite the failure of the market for altarpieces and other discouragements, including the absence of a supporting rationale, religious art continued to be produced, and by the middle of the seventeenth century (as energies of the Reformation otherwise began to decline) we have the astonishing phenomenon of Rembrandt, a master of towering achievement whose vision seems clearly to have been formed by the Reformation experience. Indeed, the importance of Rembrandt is itself a factor which should compel art historians to regular returns to the study of the Reformation, both to explicate the artist's work and to identify a tradition from which it springs.

If it is agreed that Reformation influences deserve study, there remains the considerable problem of choosing the most fruitful line of influence and that which conveys the most essential Reformation message. The movement was complex and various and can be traced through sidetracks as well as mainstreams. It is important that the two not be confused. Thus while such putative features of the Reformation 'mind' as its puritanic asceticism, its individualism, its ethical fervour, its pessimism, its democratizing impulse, and its congeniality to primitive capitalism may well be provable Reformation attitudes, what will be taken as essential in the present study is what the Reformers themselves proclaimed as essential – the evangelical doctrine of salvation through God's grace alone. Emile Mâle has made the same choice. The Catholic art of the Counter-Reformation, in his well-known account, defines itself by its various strategies for advancing orthodox doctrines of works and merit against the upstart doctrine of grace.[8]

Protestantism began as, above all, a theological cause, and despite its earnestness in attacking abuses of the old church – simony, nepotism, indulgences, greedy monks, and bawdy cardinals – its real passion was invested in theology and in redefinition of the Christian religion. Luther's conviction of his own total sinfulness, a condition which penance for particular sins did nothing to allay, became the starting point for a total reimagining, within fixed Christian points of reference, of the relation

between man and God. For most of the two next centuries this concern dominated the mental life of Protestant Europe, as a *furor theologicus* took possession of high and low, learned and unlearned, all intent on acquiring or demonstrating expertise in the fine points of salvation. It became a popular mania extreme enough to provoke conservative reaction: Dean Donne, for a notable example, complains in the 1620s that 'Resistibility and Irresistibility of grace ... is every artificer's wearing now,' and objects to having it 'served in every popular pulpit to curious and itching ears.'[9] The ears itched for nothing else, however, and popular pulpits served it in every European language.

Although this theological enthusiasm was new, there were few real novelties in the theological positions of the Reformation. Indeed, the Reformers claimed to be restorers, bent on a return to the teaching of the primitive church and the religion of the gospels, especially as this is presented in the epistles of St Paul, the study of which was a primary task of the Reformation and the starting point for heresy in Catholic countries. Earlier, of course, Paul had provided the basis for the theology of St Augustine and for the Augustinian tradition which dominated Christian thought until the ascendancy of scholasticism in the high middle ages, and which returned with vigour in the 'Augustinian revival'[10] effected by the Reformers.

The Reformation's reading of Paul concentrated, inevitably, on his scheme of salvation and his account of human sinfulness and divine mercy. We are 'sold under sin,' Paul had said (Romans 7:14), by which is meant, according to Calvin's comment, that 'man by nature is no less the slave of sin, than those bondmen, bought with money, whom their masters ill treat at their pleasure, as they do their oxen and their asses. We are so entirely controlled by the power of sin, that the whole mind, the whole heart, and all our actions are under its influence ... we are so given up to sin, that we can willingly do nothing but sin; for the corruption which bears rule within us thus drives us onward.'[11] This fact is not conclusive for us, however, since, whatever the sum of human evil, the sum of God's grace is greater. 'Grace did much more abound,' says Paul at Romans 5:20, a major locus for the doctrine, and Calvin comments: 'after sin has held man sunk in ruin, grace then comes to their help: for [Paul] teaches us, that the abundance of grace becomes for this reason more illustrious – that while sin is overflowing, it pours itself forth so exuberantly, that it not only overcomes the flood of sin, but wholly absorbs it.'[12]

Theology of course nowhere says as much, but Paul's strategy in these passages, so thoroughly congenial to early Protestantism, is evidently to

enlarge divine forgiveness by enlarging man's need for it. Clearly the forgiveness is more 'illustrious,' more abundant, exuberant, and overflowing in proportion as man's state is more desperate. Even the law is made to fit into this scheme. The ethically focused religion of the Hebrews had taught that God's approval was to be won by obedience to the law. Paul, eagerly followed by the Reformers, finds such a project hopeless. 'The law is spiritual: but I am carnal,' (Romans 7:14) and the opposition between spiritual and carnal is absolute: the 'carnal mind is enmity against God.' (Romans 8:7) God's purpose in promulgating the law is thus a staggering problem which Paul seems to explain as simply a further manoeuvre of divine mercy. Before the giving of the law there had been sin, but the sin had not been placed to man's account, put down as an offence, for 'sin is not imputed when there is no Law.' (Romans 5:13) With the law sin *is* imputed, as it must be if it is to be forgiven. And with the law there is *more* to be forgiven: 'the law entered, that the offence might abound,' (Romans 5:20) which Calvin explains as an 'increase ... of knowledge and obstinacy; for sin is set by the law before the eyes of man, that he may be continually forced to see that condemnation is prepared for him ... And farther, he who before only passed over the bounds of justice, becomes now, when the law is introduced, a despiser of God's authority, since the will of God is made known to him, which he now wantonly tramples under feet. It hence follows, that sin is increased by the law, since now the authority of the lawgiver is despised and his majesty degraded.'[13]

This emphasis on man's powerlessness to do good (or such good as will contribute to his salvation) and his wilful devotion to sin made Paul the first preacher of what Luther was to call 'passive righteousness,' in which 'we work nothing, we render nothing unto God, but only we receive and suffer another to work in us, that is to say, God.'[14] What 'we' are called upon to *do* is nothing; our only necessity is faith, and the process which is *sola gratia* with respect to God's contribution is *sola fide* with respect to man's. The Pauline teaching is strikingly epitomized in Romans 9:16: 'So then it is not of him that willeth, nor of him that runneth, but of God that sheweth mercy.' The Gentiles, by not running, may receive the righteousness that eludes the strivings of Israel, a righteousness 'which is of faith' (Romans 9:30) rather than works and consists in being reconciled to God by God's act of forgiveness rather than in moral uprightness, which the law shows us is impossible anyway. Nothing in man can initiate this reconciliation, which begins and ends in God's mercy, the workings of which are a mystery that he

refuses to unwrap: 'I will have mercy on whom I will have mercy' (Romans 9:15). The official expositors of scripture for seventeenth-century Dutch Calvinism explain that this is no mere tautology (the scriptural quotation is in italics):

For he saith to Moses, I will have mercy that is, I will really and steadfastly continue to have mercy, or more and more have mercy *on whom I have mercy* that is on whom I have purposed to have mercy, or on whom I have begun to have mercy: so that by the doubling of these words is understood the first original and perseverance therein. Is it therefore showing mercy? then it is no injustice; for mercy respects man's misery, and is a benefit which is undeserved, and proceeds from meer benevolence, and can be accused of no unrighteousness, so it can be joyned with no man's injury *and I will be merciful to whom I am merciful.*[15]

Paul's conversion exemplifies the overwhelmingness of this mercy and the surprisingness of its objects. Paul had nothing to commend him to God's special attention – he was 'a blasphemer, oppressor and persecutor' in Luther's characterization – but that is just the point. Grace operates in complete independence of works and merit, as the Dutch Annotators take occasion to emphasize in their analysis of Romans 11:6:

And if it be by grace namely that those are elected to salvation and effectually called it is no more or then certainly it is not *of works,* that is of the merits or dignity of their works *otherwise* namely, if it were of works only, or of grace and works together *grace is no more grace* namely, forasmuch as grace excludes all debt, merit or worthiness, and cannot consist therewith: for grace is in no wise grace, if it be not every way grace, Rom. 4.4. *And if it be of works, it is no more grace* namely, but a deserved reward, i.e., then their election and calling was not done of grace *otherwise the work is no more work* that is, no work of merit.

Augustine is another main figure in the history of conversion whose experience illustrated to the Reformation the inexplicable workings of God's mercy and the strangeness, in human and rational terms, of its choices. Augustine marvels after his conversion at the disproportion between the glory of God's favour to him and the meanness of his deservings. 'Who am I, and what am I? What evil have not been either my deeds, or if not my deeds my words, or if not my words, my will. But Thou, O Lord, art good and merciful, and Thy right hand had respect unto the depth of my death, and

from the bottom of my heart emptied that abyss of corruption.'[16] The persistent imagining of human helplessness and waywardness brought into line by divine solicitude seems to lead to an especially forceful use in Paul and Augustine and their followers of the traditional metaphors of father and child: 'But ye have received the Spirit of adoption, whereby we cry Abba, Father. The Spirit itself beareth witness with our spirit, that we are the children of God.' (Romans 8:15–16) Augustine writes his *Confessions* under God's prodding, but also under his protection. 'I am a little one, but my father ever liveth, and my guardian is sufficient for me.'[17] Little wonder, perhaps, that Reformation artists turned often to the scene of the father welcoming and blessing the Prodigal Son.

The workings of God's mercy stagger reason. 'How then, can these two contradictions stand together,' asks Luther, 'I am a sinner and most worthy of God's wrath and indisposition; and yet the Father loveth me?'[18] Reason balks uncomprehendingly at the 'unspeakable and inestimable mercy and love of God towards us unworthy and lost men'[19] and therefore comes under attack in Reformation writers as an obstacle to faith. For reason is superstitiously attached to the doctrine of law and works and misleads us with its disinclination to believe that God will give us something for nothing. We must give up reason (kill it, says Luther) when we try to understand God's mercy. 'The wisdom of this world,' according to Paul, 'is foolishness with God.' (1 Corinthians 3:19) The point is repeated vigorously throughout Luther's writings until in his last sermon he makes the famous attack in which he denounces reason as 'the Devil's whore,' 'beast,' 'enemy of God,' 'carnal,' and 'stupid.' Elsewhere he singles out Aristotle as reason's symbolic representative and abuses him as 'the stinking philosopher,' 'the clown of the High Schools,' 'trickster,' 'rascal,' 'liar and knave,' 'the pagan beast,' 'lazy ass,' and 'billy goat.' Some measure of the changes wrought by the Reformation can be taken by comparing Luther's billy goat Aristotle with the magnificent figure of the philosopher in Raphael's *School of Athens* painted twenty years before. Such were the overthrowings that mercy required.[20]

There is a fairly obvious sense in which the Reformation was anti-humanist and as such contradicted the spirit of the Renaissance. Its exclusive concern with the relation of God and man and, more particularly, with the process by which God saves the soul of man led not only to the despising of reason (and the concept of man's essential rationality had been the basis of Renaissance education and ethics), but to the repudiation of the cherished

humanist goal of the good life lived by the moral hero. Earthly 'happiness,' identified by Aristotle for the Renaissance generations as the 'end of man' and defined as moral and rational activity, seemed a blasphemous illusion to the Reformers, persuaded as they were that reason belongs to the flesh and that every notion of human merit detracts from the glory and the mercy of God. Mankind is 'full of sin and a mass of perdition,' and the good life is hopelessly beyond its reach. Righteousness, the good life according to the law, should not even be wished for, since our helplessness in sin is what calls forth God's redeeming grace. 'God wants sinners only,' says Luther. 'What connection could there be between abundant mercy and human holiness? If mercy is this abundant, then there is no holiness in us. Then, it is a fictitious expression to speak of a "holy man" ... for by the nature of things, this cannot be.'[21] To work for or to claim diminished sinfulness is absurd. We 'must learn from Paul' (as at Galatians 1:4) that 'Christ was given, not for sham or counterfeit sins, nor yet for small sins, but for great and huge sins; not for one or two sins but for all sins; not for sins that have been overcome ... but for invincible sins.'[22] Calvin sounds the same note. Man's nature, thoroughly corrupted by Adam's fall, is the source of those things 'called "the works of Satan"' the cause of which in fact is in man and 'not to be sought outside man's will, from which the root of evil springs up, and on which rests the foundation of Satan's kingdom, that is, sin.'[23] Nothing can close the 'distance between the spiritual glory of *the Speech* of God and the abominable filth of our *flesh*'[24] except God's grace extended in 'miraculous lenity.' Accordingly, 'whatever good things are in us are the fruits of his grace; and without him our gifts are darkness of mind and perversity of heart.'[25] Popular religion, that presumably available to painters, inevitably followed this lead. Thus, even children being led through their catechism by Dutch pastors would be taught that the 'suffering of Christ is the onely sacrifice of reconciliation,'[26] that this is the unmistakable meaning of the Apostles' Creed, and that thus is the 'dangerous error of the Romanists choked, who affirme that there must also be some satisfaction of our owne come to make up our perfect redemption, which is nothing else but shamefully and frowardly to discredit the testimonie which the Angel from heaven gave to Christ, and to weaken and overthrowe the power of Christ's merite.'[27]

Inevitably, artists had difficulty finding a language in which to express this view of things. The masters of the High Renaissance whose works proclaimed

the glory of man and the beauty of creation were still flourishing when Luther nailed up his ninety-five theses in 1517: Leonardo died two years later, Raphael three, while their contemporary Michelangelo outlived Luther himself by eighteen years. 'Life-enhancing' was Bernard Berenson's term for their special quality of human celebration: they brilliantly affirmed a vision of man and of human existence which the Reformation found it necessary to deny. How was an artist of the time to deal with this denial? The perplexity would have been especially acute for an Italian artist, or one with an Italian conception of his art, and this became increasingly common in the northern countries after Dürer. In Italy, the arts early took up a position of deliberate alliance with humanism: painters proclaimed themselves to be practitioners of a liberal art, like poetry, and laid claim to learning, genius, and inspiration.[28] It was a proud role, and in its philosophical underpinning it involved the artist in a proud doctrine. Beauty was his special field, and to exhibit its universal laws, particularly as these were observable in human bodies, was his special mission. There was a great deal of ambitious theorizing, of which the treatises of Leonardo and Dürer are famous examples.

The artist's endeavours then, were intimately bound to concepts of an ideal humanity: Castiglione's *Courtier* with its gracefulness and seriousness, its platonizing abstraction, and its earnest devotion to the idea of a perfect human being belongs to a closely parallel tradition in literature. The means for conveying this vision in art were perfected during the roughly two decades (1500–1520) of the High Renaissance, and the 'classic' style of monumental figures in a golden world, smooth generalizing of features, and symmetrically structured composition became the rule. In fact, of course, the style became inseparable from the idea of art itself to those who practised it – hence the scorn of the Italian masters for the primitive realism of fifteenth-century Northern European paintings and for the taste of Italian patrons who insisted on buying it. It is not an exaggeration to say that the only formal vocabulary available to Renaissance artists – and hence the only message – was a humanist one. The situation of an artist suddenly forced by the Reformation into possession of non-humanist or anti-humanist ideas must have been almost difficult enough to stifle expression.

The problem can be studied conveniently in the later work of Michelangelo, who of course was not a Protestant and, indeed, strove to be as faithful a son of the Church as he was the faithful servant of its popes. There is, however, considerable evidence (which is fully assembled in Charles de

Tolnay's study of the artist) to connect him with the *spirituali* led by Juan Valdés, an important group that aimed at a reform of the Church and a reformulation of doctrine in the direction already shown by transalpine Protestantism, which reform and reformulation they justified by the precedent of St Augustine. They emphasized, in the words of Benedetto da Mantova, Valdés' most widely published disciple, the desperate fallenness of man, his 'whole nature ... corrupted by Adam's sin, ... unrighteous, untrue, cruel, pitiless and the enemy of God' and the complementary message of God's 'abundance of Grace and gift of righteousness.'[29]

Michelangelo's principal connection with Valdés, or with persons actively interested in his views, was through Vittoria Colonna, Marchesa of Pescara, poet, and Michelangelo's most admired friend and spiritual teacher during the decade in which *The Last Judgment* was painted. Vittoria Colonna's association with the 'Italian Reformation' is well and variously documented: she was the intimate friend of Cardinal Pole, a central figure in the movement; her spiritual director was Bernardino Ochino, general of the Capuchins and the most brilliant and active preacher of his day, who preached salvation by grace from every major pulpit in Italy until forced by the Inquisition to flee to the north and, with other eminent religious exiles, to renounce Rome. An account (or what is represented as such) of some of her conversations with a small group that included Michelangelo has been preserved in the *Three Dialogues* of Francesco Hollanda, himself a member of the group. The conversations, held weekly in a small cloister outside Rome and devoted to topics of religion and art, were each begun with comments on the epistles of St Paul – the inevitable starting place, as in Valdés' own circle, of the partisans of faith and grace.[30] Vittoria Colonna's attachment to these central positions of the Reformation is obvious and open in her letters and poems and was widely known in her time – when only her very elevated rank saved her from the Inquisition, which in fact pursued her after her death. In a posthumous defence made for her before a tribunal of the Inquisition, it was explained that she believed 'as though only by faith she should be saved,' while, on the other hand, devoting herself to works 'as if her salvation consisted of works [alone].'[31] If this is equivocation, it is not compromise and scarcely conceals a position which the Reformation would recognize as its own.

If we are to follow Tolnay, Michelangelo's greatest exposition of the doctrine of justification by faith is *The Last Judgment*.[32] The doctrine appears also, however, in his poems which have guided interpretation of the painting:

If sometimes by your grace that burning zeal,
O my dear Lord, comes to attack my heart,
Which gives my soul comfort and reassurance
Since my own strength's no use to me at all ... (Sonnet 294)

Dear Lord alone, who dresses and strips off
Each soul, your blood its healing, its purgation
From infinite sin and from the human motion ... (Sonnet 300)[33]

The Last Judgment, begun in 1536 and completed somewhat more than five years later, was recognized by Vasari as inaugurating a second 'manner' in painting for Michelangelo. In its immense and powerful forms, massively integrated composition, and dramatic immediacy (in part achieved by the *trompe l'œil* device of painting out the wall completely, leaving no room for framing elements), it made a nearer approach to the baroque style than had Michelangelo's great ceiling in the same chapel. Also a new departure, not only in Michelangelo's individual development but also in the history of the representation of the subject, is the Augustinian and Pauline iconography of the painting. In earlier (especially medieval) art, the Last Judgment was a standard theme with established characteristics: the Judgment was treated as already accomplished in a static scene of contiguous spiritual strata occupied by the damned at the mouth of hell, the saved, the intercessory saints, and the angels. Michelangelo animates and unifies the scene, removing the intercessors and centering the action in a giant figure of Christ, who is depicted in the climactic moment of judgment (figure 1). In iconography as well as composition, Christ is the central and organizing presence. He does not share his authority with the saints, who are in Catholic doctrine the repositories of human merit. Indeed, the figures of the saints, including prominently St John the Baptist, St Peter, and the Virgin, are arranged around him in various attitudes of wonder, fear, and surprise – evidently observers rather than participants in Christ's great act. Several saints are, however, allowed their traditional attributes, symbolic of their works. Bartholomew's flayed skin is the token of his martyrdom (the Bartholomew figure is also a self-portrait of Michelangelo, as if a direct image of Sonnet 300 quoted above); Peter's keys stand for his works as head of the Church.[34]

The exclusiveness of the divine responsibility and initiative seems clear; all motion in the painting originates and ends with Christ, who dominates the scene entirely and who, even as he dissolves the creation, draws souls

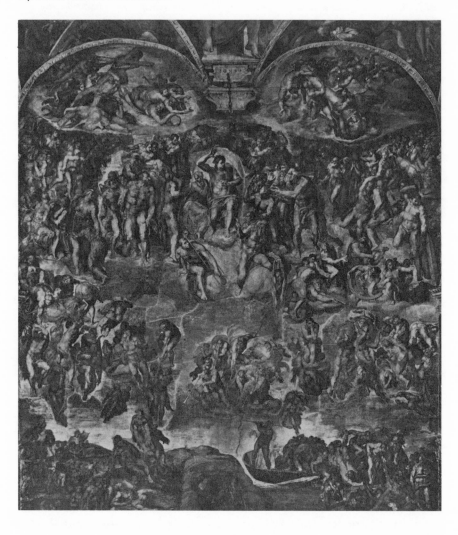

1 Michelangelo *The Last Judgment*

heavenward with an irresistible attractive power. Beginning at the lower left-hand corner, the dead are resurrected: flesh and bone are restored to each other and separated from the earth which has held them. The reconstituted bodies of the elect are then taken aloft – some with the assistance of angel-genii, others merely drawn toward the magnetic centre occupied by Christ. There is no power in the figures themselves, despite their heroic size and proportion, and their upward progress is quite evidently not a function of their own strength. Both their size and saplessness can be appreciated in figure 3. The figure type is evidently not intended to flatter the human body, and has been deplored as 'heavy' and 'lumpish'[35] – an impression heightened in the painting by the colouring, the brown tones of the figures intensifying their gross substantiality by contrast with the blue emptiness of infinite space, which is the background of the painting and almost the only other colour. They are bodies made for great gestures as part of a great action, but the action is not truly theirs, and they are arrested in a kind of slow motion – manipulated only by divine strength which is communicated in various ways (as through the assisting hand which reaches down in figure 3 and, near the centre of the painting, by a rosary), emphasizing the futility of human effort in the process of salvation. A great and terrible drama is in progress, but it is a drama in which the leading role belongs to God himself, and man appears to be deprived of every independent impulse. The exception is the 'rebellious damned,' a small group on the lower right hand side, who exert themselves unavailingly. In Tolnay's interpretation, which I have been following, theirs is the strife 'of souls who, proud of their own strength, do not believe in the power of God. This explains their abandonment by the cosmic forces. Michelangelo expresses the idea that without faith and without God's help even the most powerful are helpless.' Tolnay concludes plausibly that this episode in the painting, like the ascension carried out through faith and the magic attraction of Christ, 'is but another aspect of the doctrine of justification by faith alone.'[36]

By the time of the *Rondanini Pietà* (figure 4), his last and unfinished work in sculpture, Michelangelo has moved much further from the Renaissance forms which he had modified but not rejected in the baffled giants of the *Last Judgment* and has found a formal language better adapted to the Reformation's message of human helplessness and divine love. The frail and angular body of the dead Christ half stands, awkwardly supported by a frail Virgin who holds him from behind, both figures crushed with suffering, and deprived entirely, in Michelangelo's ascetic conception, of the attractiveness

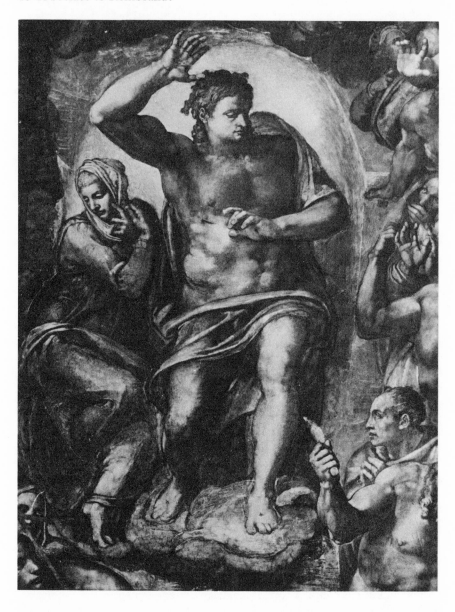

2 Michelangelo *The Last Judgment* Detail

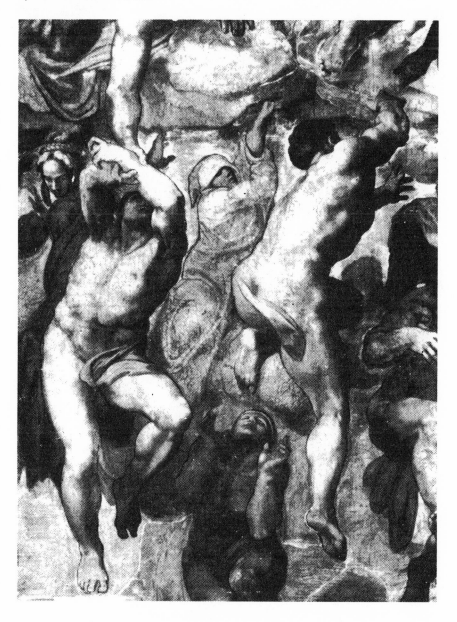

3 Michelangelo *The Last Judgment* Detail

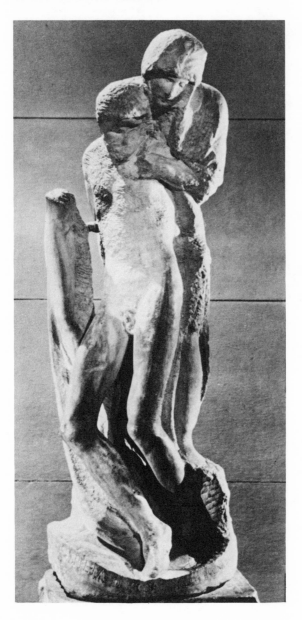

4 Michelangelo *Rondanini Pietà*

and eloquence that art might give them. They are rough in texture, jagged in outline, starved of substance, and yet the whole work, as Tolnay remarks, is infused with 'the feeling of religious beatitude'[37] – the product mainly, it would seem, of Michelangelo's sense of the immensity and completeness of the sacrifice which has been made to save men.

The sacrifice of art – in the Renaissance and humanist sense – which this vision required was also immense. According to the famous Renaissance principle (as stated, for example, by Francis Bacon) art should deliver a 'golden' world of harmony, symmetry, and fulfilled aspiration, a revelation in human terms of universal beauty. But the connection between the human and the beautiful could scarcely be maintained under the stress of Reformation teaching, and a redefinition of art seemed to be required in response to the redefinition of religion. Beauty became as problematic as wisdom, something not to be trusted in the forms in which it is conceived by man. Dürer in middle age, an international Renaissance figure, worked at his theoretical treatise on beauty and human proportion; in later years, deeply affected by the Reformation, and finding the problem unmanageable, he wrote that 'God alone knows what beauty is.'[38]

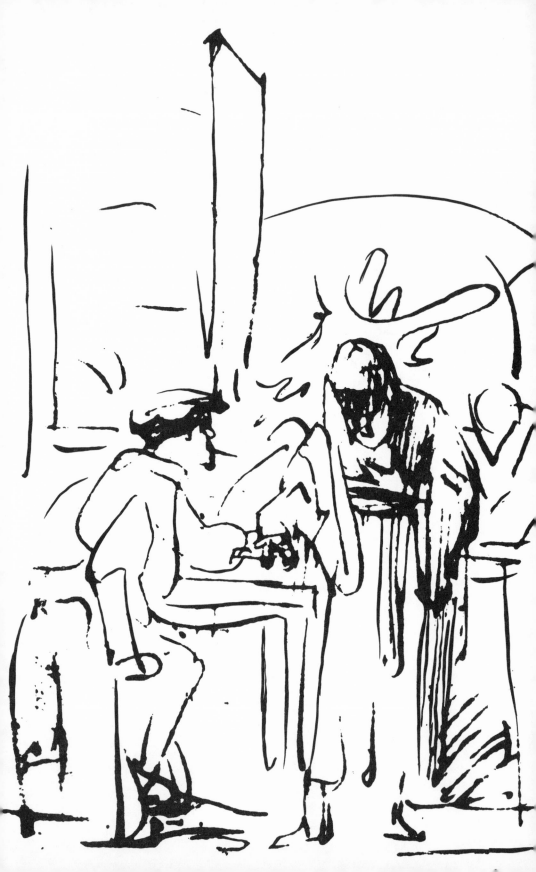

2: Calling of Matthew

A REDEFINITION OF ART did not occur, at least not immediately, and painters made shift to adapt their old modes to the new message, which made itself felt first in some new, or newly popular, choices of subject. The first of these that I shall treat is the Calling of Matthew, a quiet episode in the ninth chapter of Matthew's own gospel occurring between two disputes with the Pharisees which were themselves rich with meaning for the Reformation. In one, the Pharisees object to Jesus' having said 'thy sins be forgiven thee' to the man he cures of palsy; in the other they mutter at his eating with publicans and sinners, provoking the retort that they should go and learn what it means that '"I will have mercy, and not sacrifice": for I am not come to call the righteous, but sinners to repentance.'

Besides this interest in its immediate context, the Calling of Matthew had, of course, its own appeal as an example of God's merciful intervention in the affairs of men. Calvin's commentary draws out the unavoidable lessons:

Matthew ix. 9. *Jesus saw a man sitting at the custom-house.* The *custom-house* has usually been a place noted for plundering and unjust exactions, and was at that time particularly infamous. In the choice of Matthew out of that place, not only to be admitted into the family of Christ, but even to be called to the office of Apostle, we have a striking instance of the grace of God. It was the intention of Christ to choose simple and ignorant persons to that rank, in order to cast down *the wisdom of the world*, (1 Cor. ii.6). But this publican, who followed an occupation little esteemed and involved in many abuses, was selected for additional reasons, that he might be an example of Christ's undeserved goodness, and might show in his person that the calling of all of us depends, not on the merits of our own righteousness, but on his pure kindness. Matthew, therefore, was not only a witness and preacher, but was also a proof and illustration of the grace exhibited in Christ. He gives evidence of his gratitude in not being ashamed to hand down for perpetual remembrance the record of what he formerly was, and whence he was taken, that he might more fully illustrate in his person the grace of Christ.[1]

The *Calling of Matthew* by Jan van Hemessen (1504–55) in Munich shows how this Reformation subject might be handled by a painter concerned to make his doctrinal point (figure 5).[2] Hemessen has been inventive with the spare biblical text. The scripture says simply that Jesus 'saw a man, named Matthew, sitting at the receipt of custom: and he saith unto him, Follow me. And he arose, and followed him.' With no more than these faint hints of a

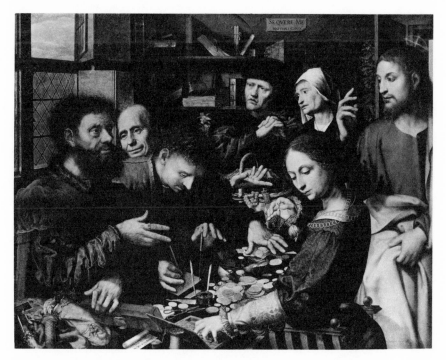

5 Jan Sanders van Hemessen *Calling of Matthew*

scene to build on, Hemessen elaborates a picture involving seven figures, and a large array of symbolic and practical objects in a detailed interior setting. (The text leaves one equally free to imagine the scene outdoors.) The composition is miscellaneous and crowded; a dominant diagonal movement from left foreground to right background works against formal balance, and supports the effect of distracting worldly business amid which Jesus and Matthew hold their silent correspondence.

Two persons in the scene are completely indifferent to what is going on. The man next to Matthew bends over his writing; the woman in the foreground who is evidently Matthew's assistant holds scales in one hand and selects a weight with the other. On the table in front of her are the paraphernalia of finance: money bags, spindles, receipts, writing quills, coins, seals, weights and ledgers. Her rich clothing betokens position in the world, but her obliviousness is total. She is specially placed – closest of all to the viewer and with her head also turned toward the viewer – to give force to the notion that the practical preoccupations of earthly life cut us off from

the things of the spirit. Across the table from her and behind the shoulder of the writing man appears a face that John Bunyan might have imagined for Mr Worldly Wiseman. It seems to show both cunning and amiability, though its expression in this scene is only ridicule for Jesus and his proposition, a response which he evidently expects Matthew to share. His hand is extended toward Jesus with index finger pointing and palm up, the terminus, it would seem, of an amused and incredulous shrug. The action of hands throughout the painting is notable: hands are everywhere, those of the worldly spectators active in grasping, writing, weighing, etc., those of Jesus calmly summoning, while Matthew has one hand pointed toward Jesus as the other quietly puts down a ledger. He is following already. ('In the great readiness and eagerness of Matthew to obey,' says Calvin, 'we see the Divine power of the word of Christ.'³)

Although the man and woman at the back of the room are familiar from another treatment of the subject by Hemessen in the Metropolitan Museum in New York (figure 7), their attitude cannot be made out with certainty. They are not indifferent to the proceedings: they look at Matthew with evident concern, and the woman's face, especially, seems to express a strong sympathy, but the general logic of the picture would seem to require this expression to be simply another variety of worldly resistance to the amazing and impractical summons. Behind them is a shelf of books and ledgers, which, with the gold and the book-keeping equipment on the table, makes up a kind of vanitas still-life. The episode has essentially the same meaning for a Reformation painter as the more dramatic – and more frequently painted – Conversion of St Paul. God in his mercy has touched the life of a man who until that moment appeared to be an impossible candidate for God's loving attention. Matthew in his milieu is mired in Augustine's earthly city, a place whose moving spirit is 'the love of self, even to the contempt of God.' If we were to judge, therefore, by human probabilities, what is in store for Matthew is 'blotting out' (the fate of those who sin against God according to Exodus 32:33). That the sinner is instead chosen to receive God's love is the miracle that the Reformation ceaselessly celebrates, and van Hemessen insists on the full Reformation emphasis. The contrasts between the vulgar vitality of the worldlings and the infinite calm of Christ, between their faces seamed with experience and his pristine smoothness, and more obviously still, between their Netherlandish costumes and his biblical robes make vivid the distance between divine and human realities. And these contrasts increase the wonder that God should come to man, while they underscore the impossibility of man raising himself to meet God.

Sixteenth-century Catholicism of course saw the relations of man and God differently. The institution of the Church itself appeared dedicated to the obliteration of the radical dualistic distinction that Augustine and Luther had placed before devout imaginations. It assumed an order of merit in society at large – an order in which the clergy occupied the highest place – and it distinguished elaborately among clerical ranks. Luther, impatient of such pretensions – even the pope was only 'a poor stinking sinner'[4] – took arms against the system of works, rewards, and 'powers' which supported them. The ancient sacraments of the Church were put under attack, the priesthood challenged, the claims of the saints denied, and the conception of salvation as a reward for virtue rejected as a grotesque superstition. Every rung of the elaborately contrived ladder by which the medieval Church had sought to move man toward God was resolutely cut away. Church historians have seen the differences between the conceptions in almost diagrammatic terms:

Protestantism, in rejecting the pyramidal institution of Roman Catholicism, rejected also much of the pyramidal philosophy with which that institution was peculiarly associated. It put in the forefront of its concerns not synthesis but conflict, not the ordered sequence of elements in human nature, but the antagonism of flesh and spirit ... It emphasized ... not the harmony of God's universe but the infinitude of distinction which separated salvation from damnation. It emphasized sin.[5]

But, as in Hemessen's painting, the Protestant emphasis on sin was not morbid, or negative, and was not aimed at inducing despair. Indeed, Augustine and the Reformers quite explicitly offered their doctrine as a specific against hopelessness; Calvin considered that his message contained 'abundant, full, and unceasing cause of joy.'[6] To recognize man's inherent sinfulness was to appreciate the immense generosity of the gift of God's grace, his infinite and self-giving *misericordia* for our dire *miseria*. Scholasticism (St Thomas Aquinas notwithstanding) had seemed to overestimate human power and desert and, in proportion, to underestimate God's grace – specifically, in a formula that recognized 'congruous' merit in man, for works not strictly meritorious but well-intentioned and therefore, in a limited sense, deserving of divine reward.[7] The Reformation never ceased objecting: 'Therefore this errour of the Schoolemen is to be corrected, who think that men unregenerate are able notwithstanding to do good works of preparation, that is, such as goe before the grace of God in us, and yet that they deserve grace of congruitie, as they barbarouslie speake.'[8]

Hemessen's painting is not, of course, fully explained by the fact that he

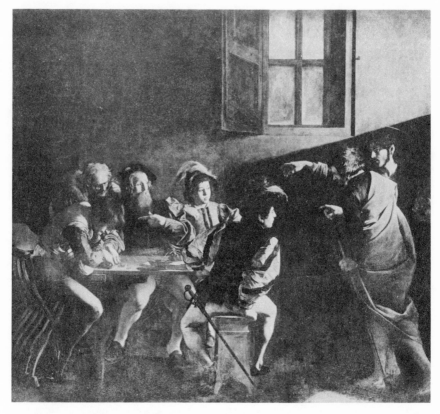

6 Caravaggio *Calling of St Matthew*

subscribed to these doctrines.[9] He was not only a Reformation painter, but also a Netherlandish one, and realism and a taste for everyday faces had been present in Netherlandish painting before Luther. But certainly the painter found no discouragement in Protestantism for these tendencies. And to his Protestantism, also, may perhaps be charged a certain tract-like literalness and solemnity in the telling of the tale. The text from Matthew, 'Sequere me,' is shown at the top of the picture as a guide to the action, and a kind of preacherly restlessness seems to be at work in pressing home points and exhausting implications. The approach exemplifies one of the meanings of the term 'literary' in painting, and one can see Hemessen as a figure in the ancestry of Hogarth.

Caravaggio's *Calling of St Matthew* (figure 6) is the most famous treatment of the subject in art and, like his *Conversion of St Paul* and *Raising*

of Lazarus, an important illustration of a Reformation idea flourishing in Counter-Reformation Italy. 'Reformation' is in this case not precise, for what is really at work in Caravaggio's religion is the intimate, simple, and direct faith of Pauline-Augustinian spirituality to which the Church had constant access through the ages, but which revived with special vigour in the Reformers of the sixteenth century – and therefore came under suspicion, when it revived in Italy, as a contamination of the 'Lutheran Pest.' Walter Friedlaender has discussed the process through which Caravaggio came into contact with this faith in the followers of St Filippo Neri, whose Roman 'low Church' appeared to threaten subversion of the official institution, ritual, and dogma.[10] Another influence from within the Church that Friedlaender traces in 'the realistic approach of the individual worshipper to the mystery of the supernatural ... expressed so impressively in Caravaggio's paintings'[11] is St Ignatius Loyola, whose widely popular *Spiritual Exercises* lent urgency and discipline to Counter-Reformation devotion. Certainly, one can see how a painter trained in Ignatius' method of schooling the imagination to feats of literal visualization – reforming will and improving understanding through a thorough-going exploitation of the senses, seeing 'with the eyes of the imagination the corporeal place where the object which he wishes to contemplate is found,' and imagining with the utmost particularity the events of the gospel and the circumstances of sin and salvation – might arrive at something like Caravaggio's emphatic concreteness in the treatment of sacred subjects. Friedlaender could perhaps claim more than he does for Loyola's influence, for a painter accepting the whole message and viewpoint of the *Spiritual Exercises* might well take from it a Protestant-like enthusiasm for transformed life and conversion. In fact, despite obvious and strongly stressed differences on such matters as the freedom of the will (to Loyola it did not seem impossible for unassisted man to choose the good and improve his capacity for it), Loyola and the Reformers appeared close enough in spirit to alarm Catholic orthodoxy. And, from the other side, Loyola has been welcomed by Protestant writers among 'those who are twice-born' and for whom conversion is the central fact of the spiritual life.[12]

It would seem self-evident that Caravaggio, as the painter of celebrated versions of the Conversion of St Paul and the Calling of St Matthew, shared the taste of sixteenth-century Protestantism and of certain currents in the Catholicism of the time for sudden spiritual renovations. And his St Matthew further illustrates the problems of ambivalence which could perplex an artist trying to convey the new evangelism in the Renaissance vocabulary of art. In

works painted very shortly after, Caravaggio adopts a flatter and more austere style, darkens his colours, deepens shadows, blurs the clear outlines of his figures, and 'avoids prettiness,' as the otherwise disapproving Bellori gives him credit for doing.[13] The development is in general toward a style of radical simplicity and minimal gesture in which drama – again, of course, with Reformation implications – is deeply internalized. In *The Calling of St Matthew*, despite its undoubted brilliance and its importance as a prototype, the style is still one of Renaissance sumptuosity and mellifluousness. The Mannerist painter and academic theorist Federico Zuccari was partly right in complaining of its derivativeness from Giorgione.[14]

Caravaggio, like Hemessen, places the scene indoors, but in a highly ambiguous setting, which does not at once declare itself to be a counting house or the office of a customs collector. Much about the picture recalls his earlier *Card Sharps*: the monumental grouping, the figure with his back to the viewer, the costumes, and the 'clear manner of Giorgione,' with its 'tempered shadows' remarked by Bellori.[15] In fact, the resemblances are close enough to have caused one of Caravaggio's seventeenth-century biographers, Joachim van Sandrart, to confuse the two paintings. He describes a picture in which Matthew is 'in the company of a gang of rogues with whom he is playing cards and dice, and sitting about drinking. Matthew, as if afraid, conceals the cards in one hand and places the other on his breast; in his face he reveals that alarm and shame which is the result of his feeling that he is unworthy to be called to the Apostolate by Christ. One of the other men takes his money from the table by sweeping it with one hand into the other, and attempts to sneak away.'[16] None of this occurs in Caravaggio's *Calling of St Matthew*, but the confusion is instructive, for it is typical of Caravaggio's purposes – and also of the purposes of Reformation art, with its doctrinal obligation to democratize spiritual life and sacred history – that his religious painting should be closely related to his genre painting.[17]

Sandrart's comment is also interesting as showing a Protestant northerner's appetite for the cruder forms of the mercy miracle. In *The Calling of St Matthew*, Caravaggio obviously recognizes the terms of the Augustinian dualism and describes the conflict between God's way and man's with a clear sense that the opposition between them is absolute and that man can be realigned with God only through the action of God's mercy. One would think this had been made clear enough in the painting: Christ motions quietly but with total effectiveness to Matthew who repeats Christ's pointing gesture as he accepts his call. Meanwhile the various representatives of human vanity

and preoccupation surrounding him demonstrate their several kinds of indifference. The young swaggerer with his back turned to the viewer – the boldest feature of the painting – admonishes us implicitly about turning away from God. His fellow across the table, also splendidly dressed, still leans casually on Matthew's shoulder while turning a face at once apprehensive and insolent toward Christ, his hard-lit roundness suggesting impermeability to godly impression. On the left side of the painting, both the old man and the young one miss the action completely as they concentrate on counting coins. The doctrine conveyed is the standard fare of the international Augustinian revival: the wind of mercy bloweth where it listeth and without regard for human merit and expectation: it can be neither stopped nor effectively solicited by men in their complete and wilful misguidedness.

But Caravaggio's treatment is more restrained than the Protestant taste of the north sometimes required or expected, and Sandrart would probably have known versions of the Calling of Matthew that sensationalized the subject as grossly as he remembers Caravaggio to have done. Another Hemessen, *The Calling of Matthew* in New York (figure 7), is such a version, complete with frantic money-grubbing and harlotry. But in fact Hemessen does not go beyond his spiritual leaders in giving ugliness to unregenerate humanity so as to stress the wonder and generosity of God's forgiveness. Luther, though more moderate on the subject than Calvin, still finds that 'human nature, in itself and apart from grace, is so evil that it neither thanks nor worships [God]. Rather, it blinds its own eyes, and falls continually into wickedness; with the result that, in addition to worshipping false gods, it commits disgraceful sins and all kinds of evil. It knows no shame.'[18] Augustine summed up human evil in the word 'concupiscence' as Paul had in 'flesh.' Essentially, both were fastening upon the principle of self which causes the man-willed breach between man and God. The 'concupiscence of the flesh,' Luther explains, means 'not only carnal lust, but also pride, wrath, heaviness, impatience, incredulity and such like.'[19] But the spiritual condition of separateness from God is an almost impossibly difficult and complex subject for pictorial art, and both Hemessen and Caravaggio (the latter much less, to be sure) tend to fall back on the root meanings of flesh and concupiscence in describing the situation of the unregenerate Matthew.

A politer treatment can lose the point, as one sees in the imitation of Caravaggio's painting by the Fleming Jacob van Oost in Bruges (figure 8). Van Oost is both less vulgar and less dramatic than either Hemessen or Caravaggio. The backward-facing bravo has taken over the scene. St Matthew

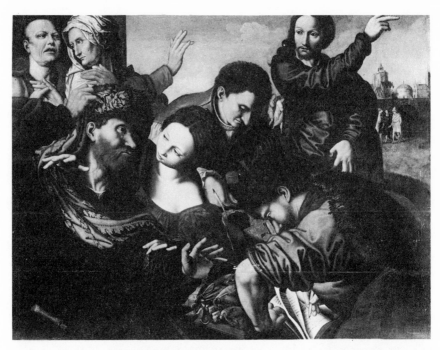

7 Jan Sanders van Hemessen *Calling of Matthew*

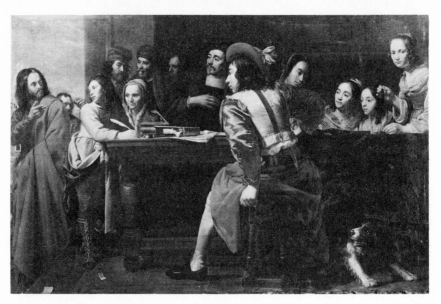

8 Jacob van Oost *Calling of St Matthew*

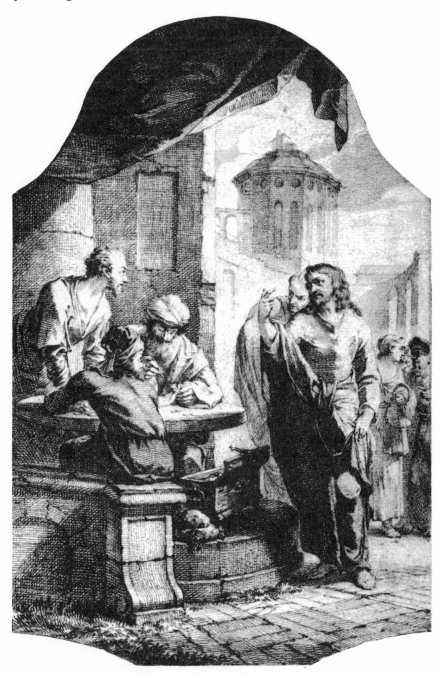

9 Arnold Houbraken *Calling of Matthew* Drawing

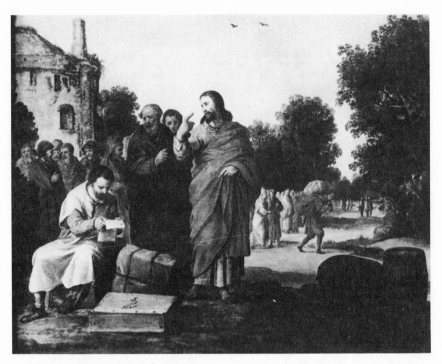

10 Jan Pynas *The Calling of Matthew*

is a half-obscured patrician in the background, and the elegant female heads might belong to his wife and daughters who gaze irrelevantly out at the viewer. In fact the picture has somewhat the air of an upper-class group or family portrait with a startling backwards figure placed in front.[20] The fine coherence of Caravaggio's picture has been sacrificed with the addition of extra figures strung out in a line and the filling up of the upper half of the picture, which Caravaggio left empty. But the main problem with van Oost's conception is that by so completely avoiding the grosser implications of 'flesh' the painter has left it unclear what Matthew is being called *from*, or why unregeneracy should be regretted.

The supernumeraries crowding van Oost's painting and strikingly present in Caravaggio's are figures borrowed from the feast with publicans and sinners at Matthew's house which immediately follows the Calling in Matthew 9 and has its own indispensable Protestant meanings. Protestant annotators were drawn to the scene of the feast for its explicit message of grace and what they took to be Jesus' repudiation of the notion that righteousness is

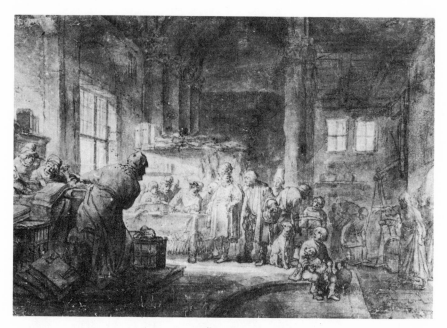

11 Nicolaes Moeyaert *Calling of Matthew* Drawing Reproduced by gracious permission of Her Majesty the Queen

humanly achievable. Thus in *The Dutch Annotations*, the Calling itself is neglected in favour of the feast and Jesus' speech distinguishing 'mercy' from 'sacrifice' and declaring his preference for 'sinners.'

I will have mercy and not sacrifice That is to say I take more pleasure in the works of mercy, amongst which also the endeavour to convert a man is principally contained, than in sacrifice *For I am not come to call the righteous* because there are none such, howsoever the Pharisees had a conceit, that they were such, Luke 18.9 *but sinners to repentance.*

It seems at least a reasonable guess that the painters' conflation of the two events so as to include sinners and publicans and, often enough, objecting Pharisees and unspecified members of the feast in the scene of the Calling is an attempt by artists with at least some small stock of theology to amplify theological resonance in a way consistent with prevailing Reformation conceptions. The Catholic van Oost's difficulties with the subject are perhaps ultimately owing to unease with those conceptions.

3: Raising of Lazarus

ILLUSTRATIONS OF THE WORKING of God's miraculous mercy were inevitably sensational, grace being always, as in the hymn, amazing. Perhaps the most sensational scene of all, the Raising of Lazarus (John 11), was much represented in Christian art from the beginning. Gertrud Schiller notes that 'the Raising of Lazarus has been represented in all periods from the early third century onwards and has never lost its important position in art,' which it held mainly by reason of its suggestiveness as 'a prefiguration of Christ and the resurrection of the dead at the Last Judgment.'[1] Clearly, the story of Lazarus had special kinds of appeal to Reformation sensibilities and was appropriated in special ways by Reformation artists. (A painting by Cranach that puts a group of Reformers – including Luther and Erasmus – at Lazarus' graveside is perhaps the most naïvely appropriative [figure 12].) The story stressed with great force the necessity and power of belief, and supported Reformation arguments that man's salvation is *sola fide*: Jesus uses some form of the word 'believe' five times in this episode in which his speeches are brief and few, and he promises that the result of belief will be eternal life and the sight of God's glory. Above all, the story stressed love. 'Behold how he loved him!' exclaim the Jews, seeing Jesus mourn for Lazarus, and their cry could be the slogan of the Reformation. Finally, of course, it insisted on the amazingness of the miracle of a man returned to life. Lazarus' death is absolute and made indubitable by repetitions of the word *death*, by Jesus' insistence to the disciples that it is not sleep, and by certifying details: 'when Jesus came, he found that [Lazarus] had lain in the grave four days already,' and Martha points out repetitiously but vividly, 'Lord, by this time he stinketh: for he hath been dead four days.' (John 11:39) And Jesus weeps with the sisters, as the presence of real death requires. Yet death is overthrown by faith and love when Jesus cries 'with a loud voice, "Lazarus, come forth,"' and, with startling effect, 'he that was dead, came forth, bound hand and foot with graveclothes; and his face was bound about with a napkin.' (John 11:44) (It is interesting that Catholic piety seized on the quiet aftermath of this episode at the home of the sisters, where Mary anoints Jesus' feet with 'ointment of spikenard' and thus enters Catholic iconography with her ointment jar, an attribute indicating the good work which is the warrant of her salvation. Reformation piety found a parable of faith and works in Mary and Martha, though they did not become especially prominent in Reformation art. Peter Aertsen's painting shows a promising polemical formula: Martha is a harried and muscular housekeeper soiled and mussed with her labour; serenely Protestant Mary, a much more refined

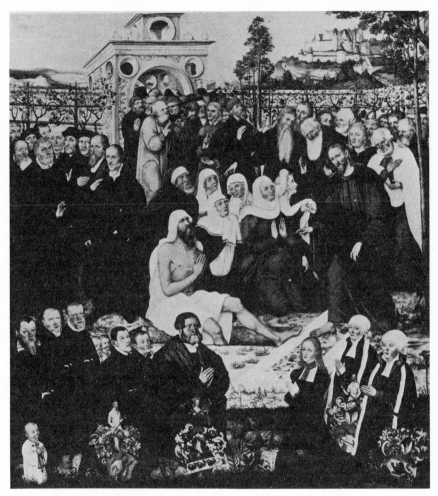

12 Lucas Cranach the Elder *Raising of Lazarus*

figure, sits quietly with Jesus, making no exertions, the passive receiver of grace [figure 13]. A drawing of Rembrandt's [Benesch 631] puts Martha at the fire with a frying pan, while Mary sits with a Bible in her lap.)

The *Raising of Lazarus* by Marten de Vos reveals some of the tensions that might exist between Reformation doctrine and Renaissance forms in a painter divided between his doctrinal and artistic loyalties. De Vos was born in Antwerp in 1532, and grew up in that city and practised his art there during a

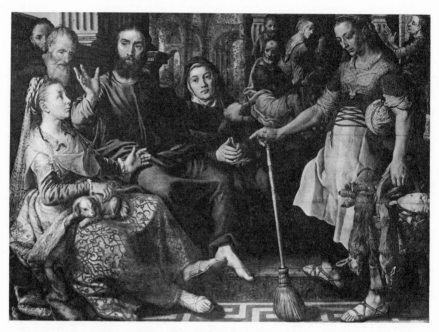

13 Peter Aertsen *Christ with Mary and Martha*

time when its Protestantism (later thoroughly suppressed) was pronounced and energetic. As a young man, however, he visited the great Italian centres and accepted influences that made him, in style and aesthetic purpose, a minor master of the humanist Renaissance. The cathedral dome and townscape of an Italian city in the distant background of his *Raising of Lazarus* are, from this standpoint, highly revealing *obiter dicta* (figure 14).

But the picture perhaps shows its affinities most certainly in its sunshine clarity. Despite the shadowy and romantic grotto provided as background setting, de Vos seems not to have the means to render mystery or to do justice to the amazingness of supernatural interventions. His figures are in the heroic mode of the Renaissance, large and handsome people, handsomely grouped and given the full dignity of the antique. They are present in some numbers, as the painter seems to aim at getting all the actors in the Biblical drama into his picture: both Martha and Mary (giving opportunity for splendour in female dress), Jesus, Lazarus himself at centre, and 'many of the Jews,' exhibiting various responses of interest, wonder, admiration, and dismay (some will go off and report to the Pharisees). The scene is full of life and beauty and flowing

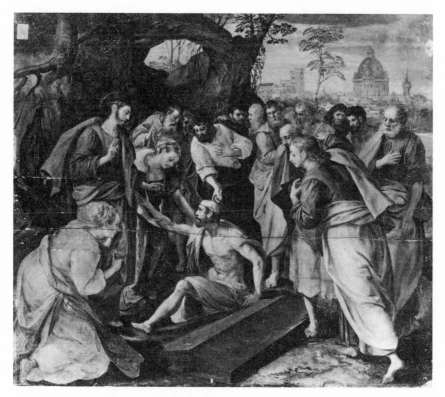

14 Marten de Vos *Raising of Lazarus*

robes accommodated in geometrically ordered space. Even the dead man reviving in the middle of the picture fails to disrupt the overall calm or to jar against the elegance. His athletic body appears to be fully alive, and his rising is managed with a movement that absorbs him harmoniously into the group surrounding him, with the tender help of one of his sisters. What Bernard Berensen would call the element of 'decoration' is dominant in de Vos' painting, and he appears to accept as fully as the most lavish Venetian the Renaissance artist's duty to present the beautiful in terms of the human.

This beauty and opulence are to some extent, though not wholly, sacrificed in the *Raising of Lazarus* by Jan Pynas (figure 15), which shows a more efficient adapting of means to ends – taking, of course, a principal end to be the exposition of the Protestant doctrine of God's mercy on sinful man. Rembrandt may have studied for a time with Pynas after leaving Peter

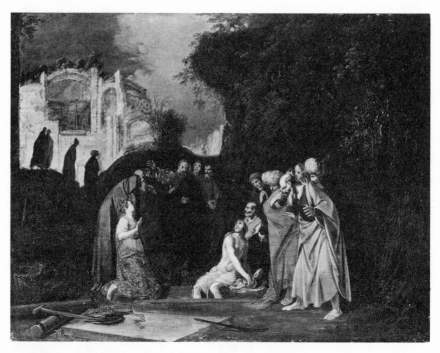

15 Jan Pynas *Raising of Lazarus*

Lastman, and the grounds of congeniality can be discovered in his painting. (A superficial resemblance shows in their 'orientalism,' consisting mainly in putting turbans on ancient Hebrews.) Compared with de Vos, Pynas makes progress towards the narrative and doctrinal compression of Rembrandt in eliminating non-essentials: the number of figures is reduced, as is their miscellaneousness of response; the interaction between Jesus and Lazarus becomes much more the focus of attention, and light and darkness are used practically to confine and concentrate the field of vision.

Beyond this, of course, Pynas' picture is clearer in its theology, or doctrinal thrust, and less at a loss in the presence of mystery. Whereas, for example, de Vos' Christ seems vague in attitude and motivation, insufficiently dominating the group, the Christ in Pynas' picture is a commanding figure whose gesture expresses the power appropriate to death's adversary (who is, by a necessary implication, also the adversary of sin). And whereas de Vos' Lazarus is so actively alive as to obscure somewhat the fact that he has been dead, Pynas' Lazarus is still not fully reclaimed from death, still weak from

the grave and dazzled by the light after his stay in the dark. Around these two stand the 'many Jews,' or their representatives – in Pynas' treatment simply a handful of people to express the astonishment which is the only appropriate response to the miracle. The landscape setting, again in Pynas' painting, makes use of a shadowy grotto and Roman ruins.[2] Pynas' handling of this, however, makes it something more than a perfunctory notation to tell us that we are entering a graveyard. It becomes an expressive part of the picture, expanding into an enveloping darkness which dwarfs and encloses the characters, conveying a Reformation message concerning human frailty and fragility.

The Reformers did not, of course, neglect the story of Lazarus in the vast effort of their scriptural commenting. Its susceptibility to Reformation interpreting (emphatic about grace) can be seen in some brief passages of Luther's 1518 Lazarus sermon. The whole piece – which is in fact a fragment – leans instructively on Augustine:

Augustine writes that we find in the Scriptures three dead persons whom Christ restored to life. First a twelve year girl ... [Matthew 9:18–26]. Second the only son of a widow ... [Luke 7:11–17]. Third Lazarus ...

According to Augustine's teaching, these three dead persons are to be understood as three kinds of sinners. The first are those whose souls have died. This is when temptation comes and conquers and captures the heart, so that one consents to sin ... The second dead person signifies those who have fallen into works, so that they have to be carried, since they cannot walk by themselves ...

Lazarus, finally, signifies those who are so entangled in sin that they go beyond all bounds; they drift into a habit [of sinning] which then becomes their very nature. They know nothing but sin; they stink and are buried in sin. It takes a lot of work [to save them] ... In this story Christ looked up to heaven and said 'Father, I thank thee that thou hast heard me,' and then cried with a loud voice, 'Lazarus, Lazarus, come out.' [John 11:41, 43]. And he came out, bound hand foot, and his face also, and the apostles had to unbind him. This is the grave, the tomb: habituation in sin.

But the main points that Luther draws from the Lazarus story are that we should distrust works when we consider our salvation (for when we trust them, 'the devil will use them for his own ends') and that we should perceive, on the contrary, how all depends on God's love expressed through Christ: see 'how kindly Christ deals with us ... See how kindly he draws our hearts to himself, this faithful God. He loves Lazarus, who was a sinner.'[3]

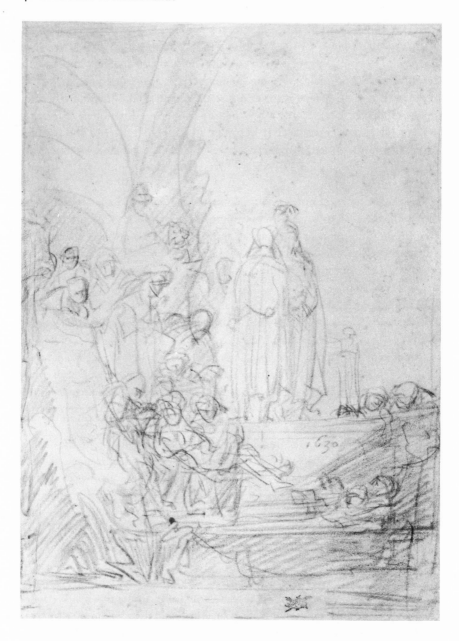

16 Rembrandt *Raising of Lazarus* Drawing

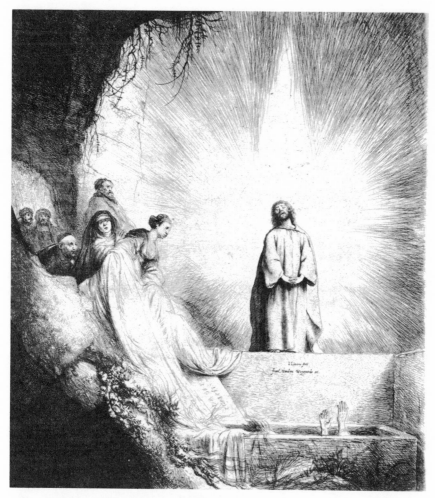

17 Jan Lievens *Raising of Lazarus* Etching

While Northern painters of this story did not adopt Luther's and Augustine's linking of Lazarus with sin, they did grasp, though not in a firm and consistent way, the evangelical point of God's loving kindness and man's dependency. Rembrandt himself appears to have drifted in and out of theological awareness. The earliest of his several treatments, the 1630 drawing in the British Museum (figure 16), is confused by overdrawing which has

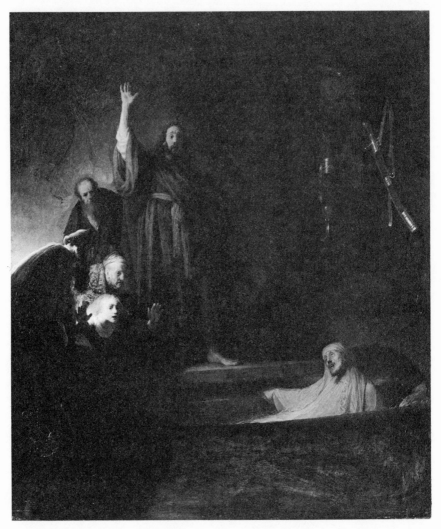

18 Rembrandt *Raising of Lazarus*

changed it into an Entombment of Christ. In the reworking, a soldier is superimposed upon the figure of Christ, and Christ is carried down into the left end of a tomb which at its right end is occupied by a crossed-out Lazarus. Fortunately, the form of the original drawing, or something closely

corresponding to it in intention, survives in a painting and an etching (figure 17) by Jan Lievens, Rembrandt's early associate in Leiden.[4]

What is most interesting in the Lievens etching, apart from its connection with Rembrandt's drawing, is its evangelical concentration. It is above all an image of Christ and very nearly an image of Christ glorified, a figure absorbed into the divine light which obliterates all other background and operates as the active power in the scene. The splendid history painting features of de Vos have not been attempted. Above all, the human actors in the scene have been sharply reduced in both size and importance. Lazarus himself is merely a pair of hands thrust up from the coffin, and Mary and Martha – active pleaders for their brother who thus perform a 'good work' in such notable Catholic versions as Giotto's and the destroyed (1945) Rubens – have become supernumeraries.[5]

Rembrandt's closely contemporaneous painting (probably 1631; figure 18) and etching (1632; figure 19), like the etching of Lievens, look back to the drawing, though less directly. They are also, for all their great impressiveness, less clear as statements of Reformation doctrine. Stechow says of the painting that Rembrandt was 'obviously determined to achieve something particularly startling,'[6] an observation that can apply to the closely related etching as well. Both are monumental in a style that owes something to the still active influence of Rembrandt's teacher, Peter Lastman. The Christ in both is heroic and statuesque, a commanding figure who more effectively expresses divine power than divine love and raises Lazarus with an imperious arm elevated above his head. (Lievens' etching and the 1630 drawing had shown him humble, standing quietly in prayer with his hands clasped in front of him.) The etching, even more than the painting, has the features of a full-dress production: costuming is elaborate and imposing, as is the arch-framed curtain hung with military bric-a-brac; the chiaroscuro is managed for stark and brilliant contrasts; and there is an overdrawn expressiveness in the staggered response of the beholders – their amazement testifying with maximal explicitness to the truly amazing nature of the event. In the late ninth state, Rembrandt changed the figure of Martha (obscured by dark inking of the left corner in many impressions) to express an anxious concern for her brother, an alternative attitude to the shock and wonder registered by everyone else. This small adjustment in the mood of the picture does little to lessen its theatricalism, however, and its seriousness remains slightly suspect. In this scene of grandly extroverted gestures, we are presented with a Christ

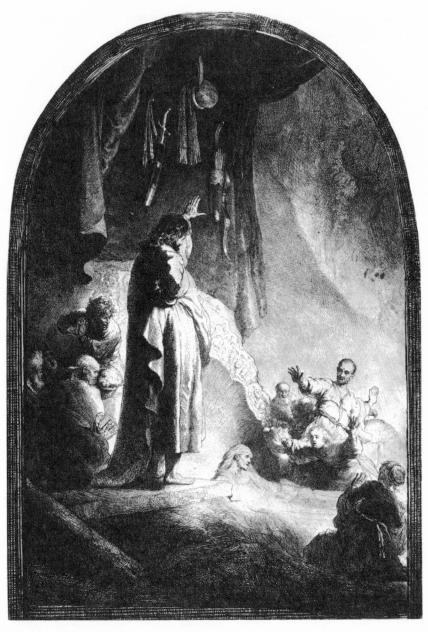

19 Rembrandt *Raising of Lazarus* Etching

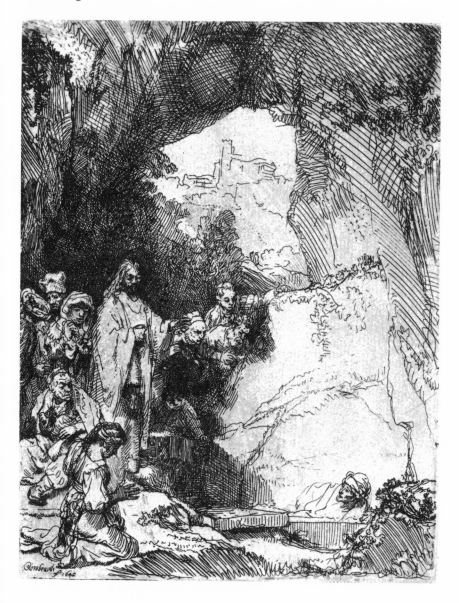

20 Rembrandt *Raising of Lazarus* Etching

imagined as Prospero, a wizard enthralling his audience with the most stunning of his tricks.

The great etching of 1642 (figure 20), Rembrandt's final treatment of the subject, provides no such diversions. Its concentrated seriousness makes its predecessor look almost trivial, and it is a seriousness that derives from a clear understanding of the main positions of Reformation Protestantism and what one takes to be a whole-hearted sympathy with Reformation spirituality. Whereas in 1632 Rembrandt evidently had nothing to say about human *miseria* and divine *misericordia* (or had lost a perspective implicit in the 1630 drawing and in Lievens' painting and etching), in the *Lazarus* of a decade later these have become his essential theme, and his procedures have changed accordingly. The human figures, for example, are not present, as in 1632, mainly to reel with shock at seeing the dead man rise from his grave, thereby providing a commentary on the pictured event while participating in it and indicating main directions for the viewer's response (he, too, should be amazed). They are, rather, images of frailty and weakness; their responses are subdued and include dull-witted incomprehension, and they huddle around and under the arms of Christ, as much the objects of his loving interest and protection as Lazarus. The scene is not so much a wonder-working as a blessing, a gift of grace shared by all of the human characters.

As in the early drawing and in Lievens' etching, the figure of Christ is in the mode of humbled godhood dictated by the belief that salvation occurs through God's self-lowering rather than through man's self-raising. His divinity has already been recognized by Lazarus' family and friends who give their attention wholly to Lazarus in the grave, who in turn looks up to Christ, establishing a communion between the chief actors in the scene which is absent from the earlier treatments: Lazarus is the sensible recipient of mercy as Christ is the deliberate and loving giver. There is thus an increased refinement and fidelity to Reformation teaching in what I shall risk calling Rembrandt's theology.

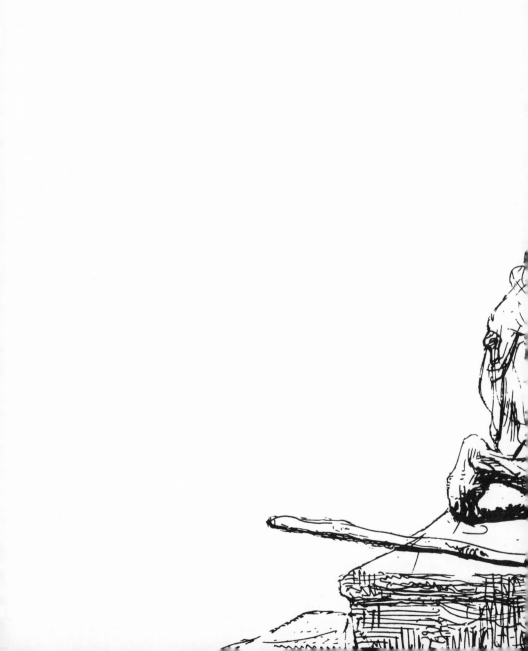

4: Prodigal Son

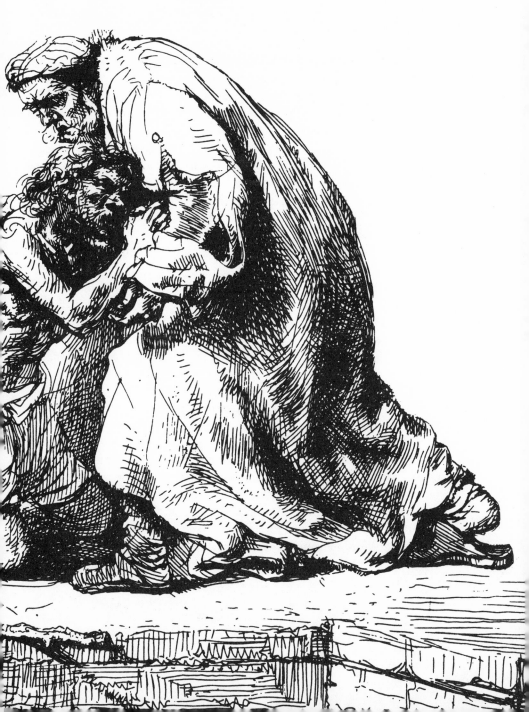

THE PARABLE OF THE PRODIGAL SON (Luke 15:11–32) had immense and impressively documented attractiveness to Reformation artists. The Decimal Index of the Art of the Low Countries has so far recorded and reproduced one hundred twenty-six Netherlandish examples in a list which makes no claims to completeness. Reasons for this popularity are not far to seek. Above all the story makes the essential evangelical point that 'joy shall be in heaven over one sinner that repenteth, more than over ninety and nine just persons, which need no repentance.' (Luke 15:7) Protestant commentators considered that the story was 'chiefly designed to set forth the grace and mercy of God to poor sinners.'[1] It showed God's promptness in reconciliation: for 'he expressed his kindness before the son expressed his repentance, for God prevents us with the blessings of his goodness, even before we call he answers.'[2] And it showed right conduct in the sinner to whom reconciliation is offered: just as the father does not stop to make conditions, so there is nothing stiff-necked in the son. Melanchthon is one who points out that 'as soon as the father sees him from afar, he pities him, runs to him, falls on his neck, and kisses him. Here the son does not run back, does not scorn his father, but instead goes also toward him, acknowledges his sin, and begs for grace ... The Son of God will be with us, come to us, and will give us aid, because he knows our misery. Only let us not push him away ...'[3]

Calvin, inevitably, finds the same lesson of the 'boundless goodness and inestimable forbearance of God, that no crimes, however aggravated, may deter us from the hope of obtaining pardon,'[4] and seizes equally strongly on the circumstance that the father does not wait for the son to approach, but 'when he was yet far off his father saw him, and had compassion, and ran, and fell on his neck, and kissed him.' (Luke 5:20) So likewise is God prompt in reconciliation and generous in going more than half-way: 'As this father, therefore, is not merely pacified by the entreaties of his son, but meets him when he is coming, and before he has heard a word, embraces him, filthy and ugly as he is, so God does not wait for a long prayer, but of his own free will meets the sinner as soon as he proposes to confess his fault.'[5] This does not of course mean, as Calvin is concerned to point out, that repentance is a precondition of grace, or that the softening of stony hearts can be self-induced. Indeed, repentance is itself a gift of God, which the parable, using a mortal father to represent the heavenly father, cannot successfully bring out. 'In short the question here is not whether a man is converted by himself and returns to him; but only under the figure of a man is commended the

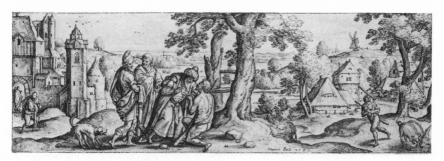

21 Hans Bol *Return of the Prodigal Son* Drawing

fatherly gentleness of God, and his readiness to grant forgiveness.'[6]

The two other parables in Luke 15 (the lost sheep and the lost piece of silver) which similarly enforce the proposition that God's mercy is available to sinners received much less attention from artists. These, however, lack the fullness, the circumstantial detail, and the pathos of the Prodigal Son story, which is perhaps Jesus' best developed narrative as well as one of his longest. The great Dutchman (and Arminian) Hugo Grotius found it 'the most remarkable [parable] of all those delivered by our saviour, as being the most passionate and affecting, set out and adorned with the most lively colours and beautiful similitudes.' The English puritan John Goodman quotes Grotius' praise and agrees that 'indeed the most powerful passions of human nature are there drawn with that admirable skill as to equal life itself.'[7] Painters, etchers, and engravers took up the tale in all its parts: The Departure of the Prodigal Son (of which Rembrandt's so-called *Polish Rider* may be an example), The Prodigal Son Wasting His Substance (which led to Hogarth's *Rake's Progress*, The Prodigal at the Trough with Swine, and, outnumbering all the others, The Return of the Prodigal Son.

Among artists the subject belongs particularly to Rembrandt, who made several returns to it and whose Leningrad painting is one of his greatest masterpieces. An earlier treatment, the 1636 etching (figure 25), will help to show something of the process by which his Reformation conceptions ripened. Like other interpreters, the early Rembrandt was attracted to the busyness and activity of the scene, with its rather large cast of characters and multiple events. There is a good deal of attention to the details of an actual homecoming, complete with all of the persons and objects indicated in the biblical account. Some of this comes to Rembrandt very directly from the woodcut of Maerten van Heemskerck (1498–1574), from which he worked

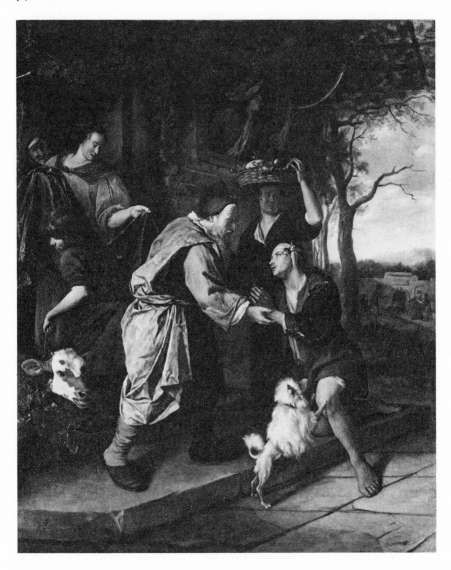

22 Jan Steen *Return of the Prodigal Son*

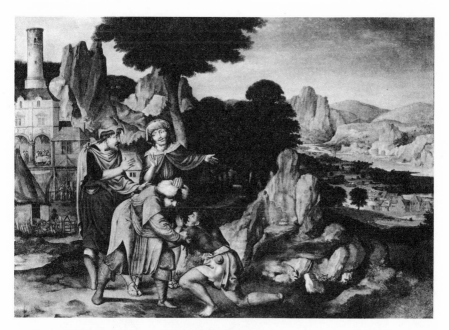

23 Cornelis Massys *Return of the Prodigal Son*

(figure 26). Heemskerck shows the fatted calf being slaughtered in the left background; father and son are still in motion at the very instant of their coming together; servants crowd through the doorway with the robes and shoes mentioned in the gospel story, and the sour face of the objecting older brother (losing out despite his record of good works) appears in the extreme upper right.

Rembrandt's dependency on Heemskerck in this print is obvious: the repetition of steps and arches, the same supplicating clasped hands of the son, the same embrace by the father, the stick in the same place, even the repeated shoulder detail of the father's sleeve, reveal the source of Rembrandt's conception. Changes are made, as in Rembrandt's shift away from Heemskerck's monumental figure, his closer combination of the main figures, and the separation of these from the supernumeraries. But the debt is clear, and it is an interesting one, for it appears to be a compliment from Rembrandt to an earlier master who, before himself, was perhaps the Netherlandish artist most strongly moved by the new religious doctrines and most energetic in testing

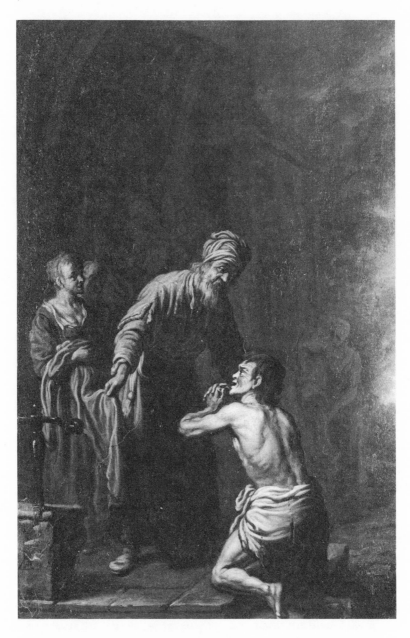

24 Peter Lastman *Return of the Prodigal Son*

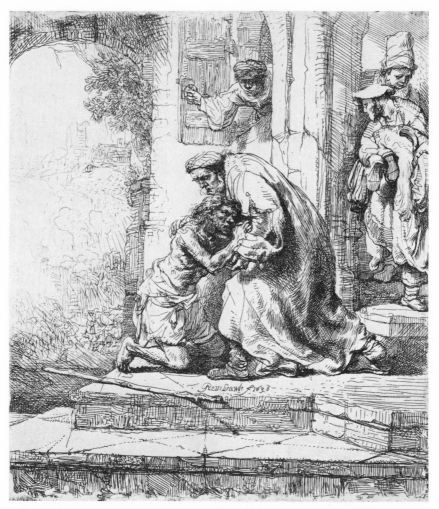

25 Rembrandt *Return of the Prodigal Son* Etching

the full range of their iconographic possibilities. Heemskerck was enor-
mously inventive and treated a great variety of biblical subject matter (mainly
in drawings which were copied by various engravers), and, like Rembrandt,
took particular interest in such subjects as The Return of the Prodigal Son,
Christ Healing the Sick, The Master Forgiving the Servant's Debt, The

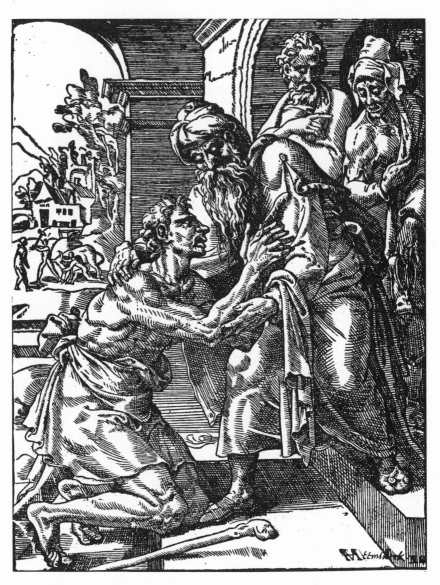

26 Maerten van Heemskerck *Return of the Prodigal Son* Woodcut

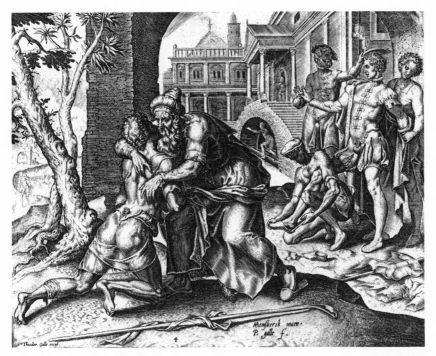

27 Maerten van Heemskerck *Return of the Prodigal Son* Engraving by Philip Galle

Conversion of Paul, all of which seemed to come already freighted with the *sola gratia, sola fide* message of the Reformation.

Another version of the Return of the Prodigal Son by Heemskerck (engraved by Galle; figure 27) illustrates a common tendency to combine episodes. The Son's welcome takes place in the foreground of the picture while he is shown being dressed in the background as three servants perform three separate but simultaneous dressing functions with hat, shoes, and robe. A contrast is intended between misery and happiness, but the interpretation seems weak and worldly. The son restored is not an image of the soul in bliss but a jaunty fop in slashed silks and codpiece. We seem far from the earnest reading of the episode by some Reformation commentators who treated the clothing as symbolic.

Bring forth the best robe – signifying the Robe of Christ's righteousness; which is incomparably, and in infinite respects the best. *We all are as an unclean thing*, and all

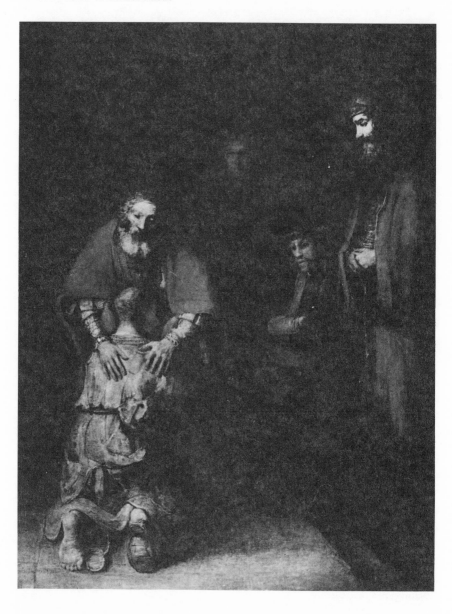

28 Rembrandt *Return of the Prodigal Son*

our Righteousnesses are as filthy rags – Isa. 64.6 ... *The Righteousness which is of God by Faith* [Phillipians 3:9], this is the best robe ...[8]

Heemskerck's figure of the son in misery is drawn with a Mannerist flair that caresses flesh, dwells on full-sculpted plastic volumes, and teasingly approaches elegance. A main part of the problem appears to be period style: some varieties of Mannerism are not better suited than the Renaissance classicism from which they develop for conveying the astringent view of man and world taught by the Reformation. But the medium of engraving seems to bring its own difficulties as well, tempting Heemskerck and Galle to flights of virtuosity that contradict the intended message of humility as the simpler woodcut does not.

Clearly, Rembrandt would not at any time have been tempted by the kind of theological allegorizing that takes 'robe' to mean 'Righteousness which is of God by *Faith*,' but he has made immense progress with an over-arching theological conception thirty years after the etching in the great Leningrad painting, 'a miracle' of his last decade which has always been recognized as an image of grace (figure 28). Jakob Rosenberg is typical in stating that the painting 'deals not with the human love of an earthy father ... What is meant here is the divine love and mercy.'[9] Love and mercy are 'meant' in an almost icon-like simplicity and stillness. The narrative has been reduced to its absolute essentials; action, in fact, has ceased, with the two main figures merged almost into one in an intensity of longing and forgiveness – 'a feeling of compassion so intense that it has the power of healing,' says Kenneth Clark in the splendid appreciation of the painting that closes *Rembrandt and the Italian Renaissance*. But father and son are not alone. As often in Rembrandt, a scene of reconciliation is given added force by putting into it one or more characters who stand outside the reconciling action, hence the shadowy onlookers, of whom one may be the virtuous elder brother oppressed by his sense of his own deservings and excluded from grace.

This survey can end with a drawing (figure 29) very closely related to the Leningrad *Prodigal Son* and which until recently was thought to be another treatment of the same subject. It is more likely to be a Departure of Tobias, but the new identification makes no essential difference to our understanding of Rembrandt's message.[10] The conception is almost identical – the slightly stiff elderly figure of the father and the youthful son bend delicately toward each other and blend into a single form, simple and austere. The signs that

29 Rembrandt *Departure of Tobias* Drawing

prove the drawing not to be a Prodigal son – the young son does not kneel, is not barefoot, and is not raggedly dressed – appear trivial beside the similarities. The images are exchangeable, and we would seem to be led to one of two conclusions by this exchangeability. Either Rembrandt was practising an exceedingly casual narrative shorthand, employing the same symbolism and dramatis personae without distinction to tell different biblical stories, or, surely more likely, under pressure of a Reformation emphasis which irresistably became his own, he extracted the same meaning from the different stories – the Departure of Tobias and the Return of the Prodigal Son being simply vehicles of that divine grace which is the abiding centre of his interest.[11]

5: The Preaching of Jesus and John

THE PREACHING OF JESUS AND JOHN was the sacred precedent for the Reformers' own endeavours and inevitably a subject favoured by painters responsive to the new teaching.[1] Christ had suffered, died and risen, he explained to the disciples after the resurrection, to fulfill the scriptural prophecy and to assure 'that repentance and remission of sins should be preached in his name, among all Nations' (Luke 24:47), and he laid upon them the duty to be 'witnesses unto me ... unto the uttermost part of the earth.' (Acts 1:8) Paul had said 'woe is unto me, if I preach not the gospel!' (1 Corinthians 9:16) Luther describes his personal office as that of preacher (in which, because he is a sinner, he does not do enough) and considers that 'the gospel is nothing else but the preaching of Christ,'[2] which is of greater value even than his works: 'If I were ever compelled to make a choice, and had to dispense with either the works or the preaching of Christ, I would rather do without the works than the preaching; for the works are of no avail to me, whereas His words give life.'[3] That we must hear the gospel preached and be moved by it to faith is a primary Reformation commonplace ceaselessly repeated as an urgent corollary of the doctrine of grace. Thus, the Hamburg Professor Jacob Kimedoncius quotes Joannes Brentius: 'We are justified (saith he) by the meere mercie of God, only for the redemption, wherewith Christ hath redeemed mankind from sinnes, and for that reconciliation which he hath obtained, and not for any merit in man. But this benefit of God we receive not but through faith by the preaching of the gospell. For albeit Christ hath redeemed mankind from sinnes and reconciled with God, yet this benefit had nothing profitted mankind, if it were not preached to them by the Gospell.'[4]

The chief reformers took their stand on preaching in defiance of forces to both left and right. Calvin maintained that it was an 'abuse and fault' of Rome to administer the sacrament without the word[5] and a dereliction of the duty which the Church was created to perform: 'that the preaching of the gospel might flourish, [Christ] deposited this treasure in the Church. He instituted "pastors and teachers," through whose lips he might teach his own.'[6] A non-preaching clergy, Calvin argued to Cardinal Sadoleto, is a contradiction in terms: 'Bishops and priests [who do not preach] are dumb statues,' and the Church of Rome has 'overthrown the ministry, of which the empty name remains without the reality.'[7] (Luther, less delicately, muttered at 'dogs who refuse to bark.') Some of Luther's argument for the necessity of preaching looks the opposite way at the excesses of spiritual confidence in such groups as the Anabaptists who thought priestly instruction unnecessary: 'So there must

be preaching and everyone must also take care that his own reason may not lead him astray. For, behold what the fanatics do. They have accepted the Word and faith, but then, added to baptism, there comes wisdom, which has not yet been purged, and wants to be wise in spiritual things. They want to master both the Scriptures and faith by their own wisdom, and they perpetrate heresy ... If we were altogether pure, we should have no need to be admonished, but would be like the angels in heaven with no need for a schoolmaster, and do everything willingly of ourselves.'[8] The main function of preaching, however, is not this admonitory one, but rather to make it possible for the Christian to take Christ to himself:

Rather ought Christ to be preached to the end that faith in him may be established that he may not only be Christ, but be Christ for you and me, and that what is said of him and is denoted in his name may be effectual in us. Such faith is produced and preserved in us by preaching why Christ came, what he brought and bestowed, what benefit it is to us to accept him. This is done when that Christian liberty which he bestows is rightly taught and we are told in what way we Christians are all kings and priests and therefore lords of all and may firmly believe that whatever we have done is pleasing and acceptable in the sight of God.[9]

More than the preaching of Christ, the preaching of John is a picturable, even a picturesque, subject (figures 30 and 31). 'In those days came John the Baptist, preaching in the wilderness of Judaea, And saying, Repent ye: for the kingdom of heaven is at hand. For this is he that was spoken of by the prophet Esaias, saying, The voice of one crying in the wilderness, Prepare ye the way of the Lord, make his paths straight. And the same John had his raiment of camel's hair, and a leather girdle about his loins; and his meat was locusts and wild honey.' (Matthew 3:1–4) It is not surprising that painters should have been attracted to this scene, as in fact they were in rather large numbers. The Netherlands Institute for Art History (in DIAL) has thus far indexed eighty-one examples, a richness making it something of a puzzle that Visser 't Hooft, himself an extremely prominent Protestant churchman, should think Rembrandt's interest in John's preaching 'strange.'[10]

Both scenes have landscape interest, which rather frequently in pictures of Jesus preaching includes the interest of sea and ships (figure 32). And both tend to allude, topically in the sixteenth-century Netherlands, to contemporary field preaching which drew immense crowds to areas outside the cities to hear Protestant preachers forbidden in the churches by the Spanish government.

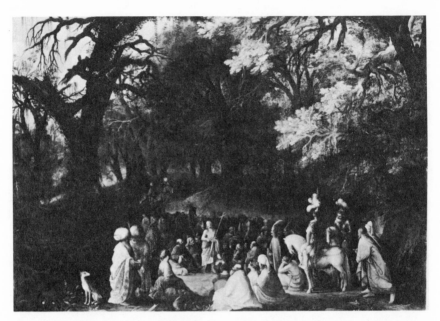

30 Adriaen van Stalbent *John Preaching* Formerly attributed to Adam Elsheimer

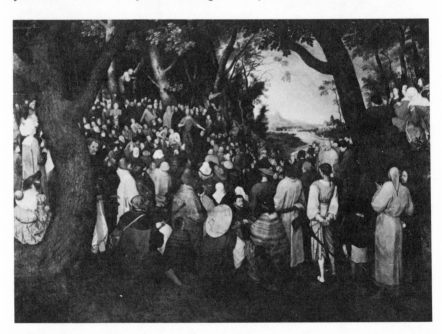

31 Peter Brueghel *John Preaching*

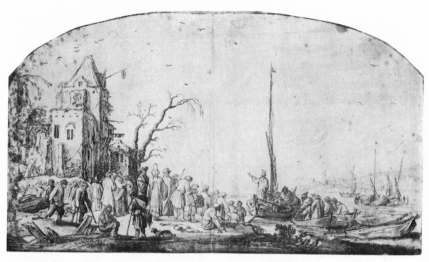

32 E. van de Velde *Christ Preaching from a Ship* Drawing

Some of the preaching in fields was regularly scheduled and became a standard form of Protestant worship: an elaborately built pulpit and canopy which stands on display in the Library of the Societé de L'Histoire du Protestantisme Français in Paris shows that Protestant preachers in some locations accepted open air arrangements as more or less permanent. In other places arrangements might be inpromptu, often depending on the availability of such famous traveling preachers as Herman Moded of Zwolle who held giant meetings in the summer of 1566 in the outskirts of Ghent, Brussels, and Antwerp.[11] The first important historian of these events, Gerard Brandt, writing a century later, described some of these early improvised arrangements, also the early-developing association of psalm-singing with preaching in these beleaguered Protestant congregations.

They made a kind of Pulpit of Planks in haste [23 July, 1566 at Ghent] and set it upon a Waggon which *Striker* ascended and preached in. When Sermon was done, all the Congregation sung several Psalms: They likewise drew some Water out of a Well or Brook near them, and baptized a Child. Two days were spent here after the same manner; then they adjourned to *Deinsen*, afterwards to *Ekelo*, in the District of *Bruges*, and so through all *West Flanders*. At that time Peter Dathenus preached at *Poperingen* in the same Province. He had been a Monk there, and after quitting his Cloyster, staid a while among the *Reformed* in the *Palatinate*: but upon this new turn of affairs came back to his own Country, after having translated the Psalms of *Clement*

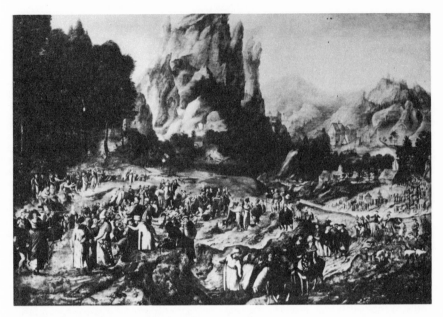

33 Herri met de Bles *St John the Baptist Preaching*

Marot and *Theodore Beza* into *Low Dutch* Metre, adapted them to the French tunes and measure, and published them with a Dedication to all the *Netherlandish* Congregations and their Pastors groaning under the Cross. These Psalms were in a little time used wherever the publick preaching prevailed.[12]

The numbers grew larger (as Catholic Peter Brueghel shows in a densely crowded small painting [figure 34] of which his sons made several copies) and defensive arrangements more elaborate, as nationalism and anti-Catholicism became more militant:

The Calvinists observed a certain order in their services. The women sat in the middle inside a circle marked out with stakes and cords; their servants and soldiers, who kept guard, formed fighting-order after the sermon and then they fired stray shots and now and then would shout 'vive les geus!' [a cheer for the 'sea-beggars,' or anti-Spanish privateers] At Ghent the assemblies outside the town were commonly twenty thousand strong, and were attended by people from other places where there was no preaching. And if there should happen to be two successive holy-days, then they

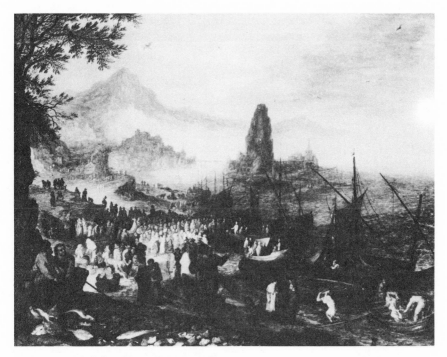

34 Jan Brueghel the elder *Christ Preaching*

stayed the night there, so that they should not have to come back, and cooked their food in the fields. So it was throughout almost all Flanders, Holland, and Zealand.[13]

Rembrandt's preaching scenes have no such crowds and no such contemporary references. In fact the most celebrated of them, the etching of *Christ Preaching the Remission of Sins* (the so-called Petite Tombe), is intimate and small-scale in the extreme (figure 35). The subject is not a single gospel episode, but a characteristic activity of Christ that summarizes the meaning of his career, to an early Protestant sensibility, almost as efficiently as the sacrifice on the Cross. The 'good news' of the Gospels is precisely the remission of sins, of which Jesus was both messenger and agent. In that double role, his preacherly function is a special one and distinct from such other preacherly functions as admonition and exhortation (St John can be seen exhorting in Rembrandt's painting in Berlin, figure 36).

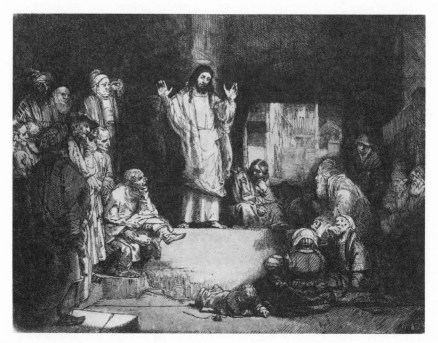

35 Rembrandt *Christ Preaching the Remission of Sins* Etching

Rembrandt's etching is based on an engraving by J. Collaert after a drawing by Marten de Vos entitled *Remissionem Peccatorum* that shows St Peter preaching to a miscellaneous assembly of people including soldiers, nursing mothers, and children of various ages (figure 37). Despite the directness of the borrowing (note especially the large figure in the left foreground) the feeling of the print is very different from Rembrandt's: Peter is statuesque and imperious; the foreground figures have the exaggerated muscular grace of Flemish Mannerism; the audience, though attentive to the preaching, is not in any sense unified by it, each individual occupying his allotted space and sharing an even illumination. Rembrandt encloses the space, with advantages of both formal coherence and expressive efficiency. The background is simplified; the figures are contained by the enclosure and arranged more or less in one plane; they are moved closer to Christ and unified by their separation from the surrounding darkness; light descends from above. Although the figure of Christ is that of a humble person among other humble people, his dominance is made more secure by Rembrandt's

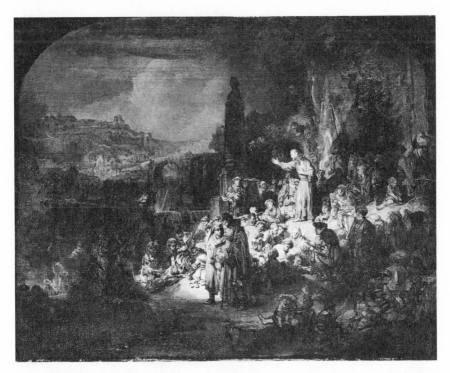

36 Rembrandt *Preaching of St John the Baptist*

careful positioning; the higher dais, the circular organization with Christ in the middle, the column moved from the left rear of the earlier picture to become a strong vertical accent at dead centre, directly behind and over Christ. A main point of both scenes would seem to be that the remission of sins applies universally to all human types and conditions. Yet we can hardly understand what in the elegant perfection of de Vos' people needs forgiving, and their facial expressions tell nothing of their response to what they hear. Rembrandt, as always, avoids the stereotypes of perfection and imagines his scene with careful attention to human response – in this case, to be sure, an inadequate response, but one true to the facts of human nature and divine mercy as Rembrandt understands them. His people are little worldlings, with their foolishness and vanities still upon them, in whom a cautious and wondering thoughtfulness has been induced. Their puzzled faces proclaim that the miraculous gift is beyond human power to grasp, while above them

37 J. Collaert after a drawing by Maerten de Vos *Remissionem peccatorum*
Engraving

God as Christ raises his hands in what Kenneth Clark finely describes as a 'sublime gesture of all-inclusive forgiveness and benediction.'[14] For Rembrandt's Christ, to preach the remission of sins is not to describe a doctrine abstractly but to perform the blessing and deliver the forgiveness.

To Rembrandt, forgiveness implied forgivability, and this etching makes especially moving use of the child-like figures that I shall argue in a later chapter are essential to his representing of the Reformation's view of man and its scheme of grace. The old man leaning toward Christ at the right of the picture, short and eager, with his oversize head and the roundness of overall form that he shares with the other old men around him, with his hint of clumsiness (or at least of physical restriction), shows that child-likeness is not incompatible with age. Among the doubters who occupy the left half of the picture, the man who sits chin in hand, elbow on knee, leg raised onto Christ's platform embodies childish impertinence in his scepticism. Above all, the woman who replaces the two statuesque females in the right foreground of the de Vos shows the completeness of Rembrandt's program for changing grown-up human beings into children whose helplessness invites and explains divine compassion. Though evidently the mother of two children (she can scarcely be a nursemaid and derive from the splendid mothers of de Vos/Collaert) she has been made into a child herself. She sits careless of her skirt with her knees spread wide. She is childishly short-waisted, and her little round back and little round head turned so completely away from us express a childish intensity of absorption.

6: Blessings and Healings

I N ITS DESCRIPTION of Nicholaes Maes' *Christ Blessing the Children* (figure 38), the London National Gallery catalogue of the Dutch school mentions that the subject is 'not so rare in Dutch art as has been thought.'[1] It is in fact no rarer than other mercy motifs to which Reformation artists were drawn; and, taken together with other blessings and healings with which it can be grouped, it constitutes an important subject of sixteenth- and seventeenth-century Reformation art. In commenting on Mark 10:13 following, Calvin shows its special usefulness to the beseiged theological centre in the sixteenth century, as concerned with Anabaptists at one extreme as with Rome at the other.

[Jesus] declares that he wishes to receive *children*: and at length, *taking them in his arms*, he not only embraces, but *blesses* them by the *laying on of hands*; from which we infer that his grace is extended even to those who are of that age. And no wonder; for since the whole race of Adam is shut up under sentence of death, all from the least even to the greatest must perish, except those who are rescued by the only Redeemer. To exclude from the grace of redemption those who are of that age would be too cruel; and therefore it is not without reason that we employ this passage as a shield against the Anabaptists. They refuse baptism to *infants*, because infants are incapable of understanding that mystery which is denoted by it. We, on the other hand, maintain that, since baptism is the pledge and figure of the forgiveness of sins, and likewise of adoption by God, it ought not to be denied to *infants*, whom God adopts and washes with the blood of his Son.[2]

Several painted versions are Rembrandtesque, including the National Gallery's Maes, evidently a youthful picture painted while Maes was a student of Rembrandt's around 1650 (figure 38). Like some other examples it combines religious painting and genre: one child receiving the blessing is puzzled and apprehensive, not sure why she is there. The Mother anxious for her and wanting her to make a better impression seems to chide gently. Another child is hoisted up behind to get a better view, as plain people crowd around the miracle of divine love as they might around an organ grinder. A Hoogstraten drawing of the subject (figure 39) is more convincingly Rembrandt-like, though still lacking force and point when compared to Rembrandt's 'Hundred Guilder Print' (figure 75). Another Rembrandt follower, Jacob de Wet (figure 40), gives the scene imposingness with columns and arches and employs a dramatic chiaroscuro in which superna-

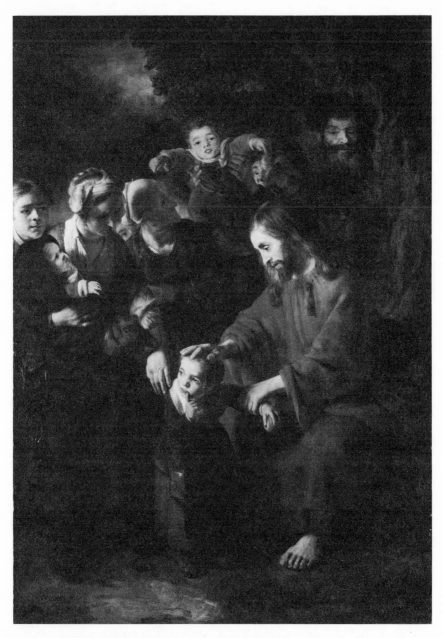

38 Nicolaes Maes *Christ Blessing the Children*

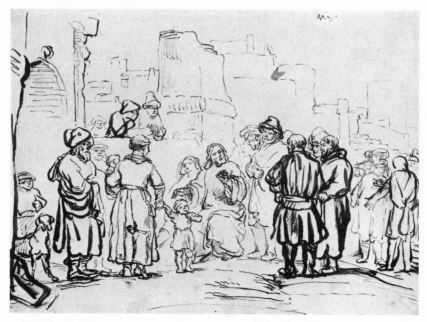

39 Samuel van Hoogstraten *Christ Blessing the Children* Drawing

tural light illuminates supernatural benediction. Here, as in Maes, some genre elements appear – the wispy-haired mother, the children in moods varying from boredom to distress – though much less obtrusively.

Outside the Rembrandt tradition, it is not always clear that the artists know what they should be getting from the subject. Perhaps here, especially, it is possible to feel that a Reformation subject had to wait for Rembrandt in order to be fully possessed. It was, however, introduced very early in the Reformation by Cranach whose painting, which exists in four versions painted by himself, became the prototype of several more paintings by his workshop and by Lucas Cranach the younger. A connection between Cranach and the Reformation has, of course, never needed proving – he was fond of painting Reformers, his friendship with Luther is well-known, and he may in these paintings be carrying out a specific Reformation assignment, creating 'a pictorial expression of Luther's opposition to the Anabaptists.'[3] The position does not change, as we have seen, for the followers of Calvin.

Early treatments of Christ Blessing the Children are often group portraits. In fact, the subject continues through Van Dyck to provide a favourite

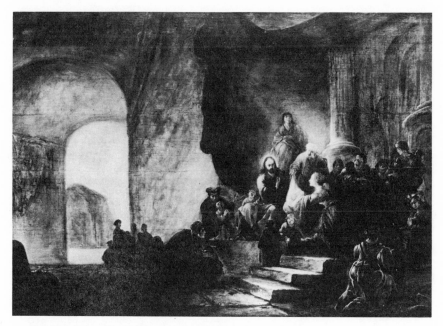

40 Jacob de Wet *Christ Blessing the Children*

formula for the *portrait historié*.[4] The picture by Hieronymus Francken the elder (figure 41) is as head-filled as a sheet of postage stamps, and with something of the same effect of duplication. To be sure, Christ is the major figure in the group, but he is far from dominating it (or even getting its attention) and the mercy message is almost forgotten. Werner van den Valckert's painting (figure 42) is also the work of a portraitist and digresses from the theme of mercy in much the same way. The conception is both Northern and Protestant in its naturalism: the blessing takes place in a common street scene, with the only elements of extraordinariness provided by the fanciful architecture. Christ is gentle in the laying on of hands, but it is the vitality of the crowd and the strongly marked facial types that dominate the picture, preventing any real concentration on the theme of mercy.

The Blessing of the Children by Vincent Sellaert (figure 43) gains coherence by omitting portraits and to a considerable degree Italianizing the subject in the manner of Leonardo, whose presence can be felt in softness of modelling and 'poetic' expressions. But Sellaert's approach is still basically that of a democratizing, anecdotal, devout Netherlander responding some-

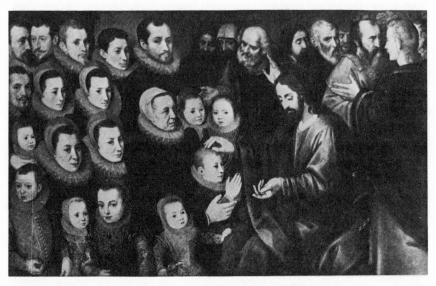

41 Hieronymus Francken the Elder *Christ Blessing the Children*

what naïvely to the new evangelism. The scene has somewhat the look of going-home time at a nursery, with swarming children attended by an equal number of mothers. Christ, benevolent and perhaps a little humorous, is the principal figure in the group, but has nothing about him to suggest that he is a third part of the Christian Godhead. The horizontal construction of the scene denies him the pyramid-topping authority aimed at in later baroque versions (see Jordaens, figure 46) and, in fact, he is thoroughly absorbed into the busy scene. About him are the apostles and the muttering Pharisees who figure in all three scriptural accounts of the episode (Matthew 19, Mark 10, and Luke 18), and who in their moral arrogance contrast with the obvious helplessness and lack of moral pretension in the children – creatures in whom the claim of merit would be absurd, but who are 'of ... the kingdom of God,' which they 'receive' (Mark 10:14–15, Luke 18:16–17) passively, as, according to Reformation teaching, it must be received.

Naïvety gives way to conscious grandeur in later Mannerist versions, but without clear gains in comprehension or in adapting form to Reformation content. The painting by Cornelisz. (figure 44) has the characteristics of the so-called Haarlem academicians: monumental nudes, or semi-nudes, a somewhat stiff rhetoric of exaggerated poses, a muted color, and a rather rigid relief-like organization of space. One can feel here as elsewhere that a

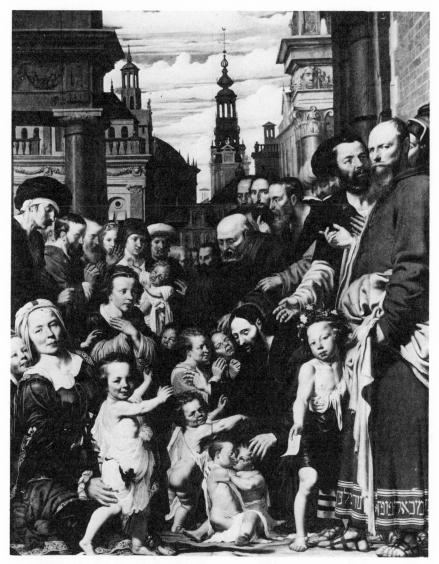

42 Werner van den Valckert *Christ Blessing the Children*

painter's interest in the grand and imposing involves a misunderstanding and that 'Renaissance' lessons will have to be forgotten before the new doctrines will find adequate expression in art. Adam van Noort's painting (figure 45) similarly insists on the importance of the scene without doing much to explore

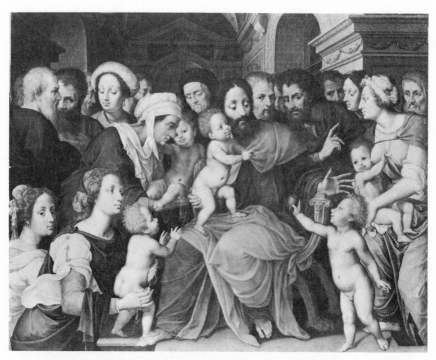

43 Vincent Sellaert *Christ Blessing the Children*

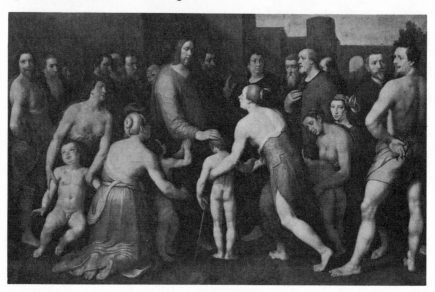

44 Cornelis Cornelisz. *Christ Blessing the Children*

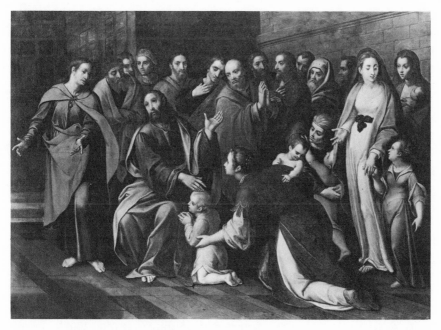

45 Adam van Noort *Christ Blessing the Children*

or explain its evangelical meaning. Although momentousness is declared in a variety of emphatic gestures, ideological pressures are not being concentrated to give force to the message of mercy.

Van Noort, a man of the south and a Protestant teacher of the Catholic Rubens, is a figure with whom to raise the question of differences between the schools of north and south. These differences should not be exaggerated. Van Noort, for example, though a Fleming (or what would eventually be called one) would have thought of himself as simply a Netherlander and of northern Netherlandish art as more or less seamlessly continuous with that of the south. A distinctly Dutch art did of course develop in the first half of the seventeenth century, but there is evidence that artists and patrons continued long into the period to regard Netherlandish art, both northern and southern, as a whole. Constantine Huygens, for example, an early patron and critic of Rembrandt and Lievens, and, as secretary to the Stadtholder Prince Frederick Henry of Orange in the thick of Dutch politics and developing nationalism, discussed the great Netherlandish painters without distinction between Dutch and Flemish.[5]

Moreover, *Dutch* and *Flemish*, even later in the century, did not with

certainty denominate Protestant and Catholic. Jacob Jordaens, the great Antwerp painter, became a Protestant and thrived with the aid of major Church commissions. A forerunner less lucky in his time was Jan Massys, son of Quinten, who was banished from Antwerp as a Protestant in 1544, though allowed to return in 1558. Dutch Catholics, on the other hand, included Adriaen van de Velde, van Goyen, Steen, and Vermeer (a late convert), as well as the continuously active community of Catholic artists in Utrecht. But Catholic painters did not necessarily produce Catholic art. Baruch D. Kirschenbaum rightly points out in his study of Steen that, 'Catholic though he was, Steen made pictures befitting the larger religious environment in which he lived. He was in iconography and treatment essentially Protestant in his religious painting.'[6]

The Utrecht group, leading purveyors of Italian influence, should remind us of the integrating role of the Italian journey, which was *de rigueur* for Netherlandish artists of north and south alike, and could only be neglected by such a strong and independent spirit as Rembrandt (also Hals and Vermeer). Another who never crossed the Alps was Jordaens, though Italian influences, reached him through Rubens. His *Christ Blessing the Children* (Copenhagen; figure 46) is a splendid fleshy picture with chubby putto-like children and ample-breasted mothers in the kind of grandiose architectural setting that a Venetian artist might provide. (The dogs, of which the scriptural account makes no mention, are reminiscent of those that Veronese included in his *Feast of Cana*.) The composition places Christ at the still point of an active pyramid of bodies, somewhat removed and in relative darkness, almost a Christ enthroned whose general form perhaps owes something to Last Judgment scenes, including Michelangelo's. The picture is not notably Protestant then in style, though the Biblical incident makes a useful Protestant point against those who claim righteousness on the basis of works (self-evidently not within the capabilities of children) and provides matter useful in demoting the saints – who, though the best of men, were only men and hence, in the rigorous view of early Protestantism, not free from human evil and error. Matthew 19:13–14: 'Then were there brought unto him little children, that he should put his hands on them, and pray: and the disciples rebuked them. But Jesus said, Suffer little children, and forbid them not, to come unto me.' Thus, in the biblical account, the saintly disciples function not as intercessors for divine favor, but as obstacles to it. Calvin sees their mistake both as natural enough for those who judge 'according to the feeling of their flesh' and as a foretaste of mistakes the Church would make.

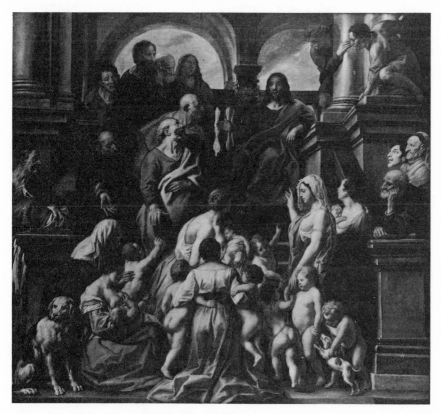

46 Jacob Jordaens *Christ Blessing the Children*

They reckon it unworthy of his character to receive *children*; and their error wanted not plausibility; for what has the highest Prophet and the Son of God to do with *infants*? But hence we can learn, that they who judge of Christ according to the feeling of their flesh are unfair judges; for they constantly deprive him of his peculiar excellencies, and, on the other hand, ascribe, under the appearance of honour, what does not at all belong to him. Hence arose an immense mass of superstitions ... We see what happened with Popery. They thought that they were conferring a great honour on Christ, if they bowed down before a small piece of bread; but in the sight of God it was an offensive abomination. Again, because they did not think it sufficiently honourable to him to perform the office of an Advocate for us, they made for themselves innumerable intercessors; but in this way they deprived him of the honour of Mediator.[7]

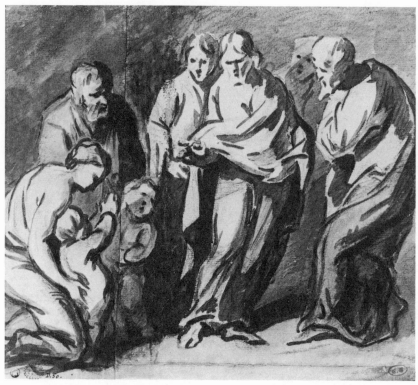

47 Attributed to Jacob Jordaens *Christ Blessing the Children* Drawing

Jordaens has the disciples stand to one side, the rebukers rebuked and
humanly puzzled at the queer and unaccountable directions taken by divine
love.

If Jordaens' Copenhagen *Blessing* can be said to be epic in conception, the
drawing attributed to him in the Besançon Museum (figure 47) is lyric: fluid,
graceful figures drawn with quick strokes, Christ placed among men at a
human level, the chiaroscuro used not to emphasize divine mystery but to
make all of the participants sharers in the light. The Protestant preoccupation
with the divine gift is perhaps clearer here.

Rembrandt had good reason in the 'Hundred Guilder Print' to treat the
Blessing of the Children together with the Healing of the Sick as essentially
one subject illustrating God's activity in 'reconciliation' and 'adoption.' This

conflation is anticipated in the gospel accounts where Jesus mentions the young, the sick, and the poor as categories of human helplessness which call forth divine help, examples of the last who shall be first. And the mixed scene of Blessing and Healing is, of course, faithful to ancient (and Reformation) commonplaces concerning the nature of God and the nature of man. God is both father (for Paul, 'the Father of mercies, and the God of all comfort,' 2 Corinthians 1:3) and physician. Man 'imputed' righteous and 'adopted' is the *child* of God: 'We have the word,' Luther says, 'which makes us God's children.'[8] We are also patients, for mankind is *sick* with sin: 'Do you still not see your sickness,' Luther asks, 'don't you want forgiveness of sins?' And will you not go to 'this physician, who has given his body?'[9]

The following plates illustrate healings from the early sixteenth to the late seventeenth century. *Christ Healing the Blind Man* (figure 48) by the Master of the Gathering of the Manna is a very early (pre-Reformation) procession painting showing Christ stopped at several points along the road to minister to the miserable. The multiplication of events and characters aims at the effect of crowded misery as 'they came to him from every quarter' and 'pressed upon him.' The painting by Hans von Aachen (figure 49) is a non-Netherlandish example, though the painter had many connections with Netherlandish artists and is given a place among them in van Mander's *Schilderboeck* (1604). In style, he is a mannerist closely following the Venetian Tintoretto whose elegance does not adapt easily to the Reformation's theme of human desolation and need. The ship in David Vinckeboons' painting (figure 50) is a reminder of this intensity of misery crying out for relief. When Jesus went to the sea from Galilee 'a great multitude came unto him,' and he requested of his disciples 'that a small ship should wait on him because of the multitude, lest they should throng him.' (Mark 3:9) Nothing else in Vinckeboons' painting, to be sure, hints at this thronging unhappiness, and in fact Vinckeboons takes a wholly different direction in exploiting landscape to convey a mood of all-embracing reconcilement. The pain of human misery has been eased by the ministration of divine love, and the painter describes a condition of blessedness in nature. Van Uden's painting (figure 51), also, is one that uses landscape as a primary vehicle for suggesting the condition of grace, with the figures made small and enveloped in a wide and consoling space. Clearly, it is beyond the scope of the present study to attempt the argument, but the possibility can at least be suggested that this vision of a divinely induced stillness in nature is peculiarly Protestant (perhaps deriving from Protestant familiarity with the Book of Psalms) and is identical

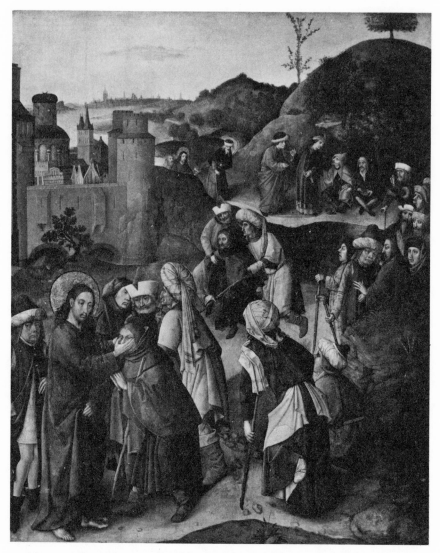

48 Master of the Gathering of the Manna *Christ Healing a Blind Man*

with the vision that informs the great masterpieces of Dutch landscape painting, including Rembrandt's.[10]

Vinckeboons was a refugee from Antwerp who set up in Amsterdam. Jordaens, as I have mentioned, was able to practice his Protestantism and stay in Flanders. In the examples shown, Jordaens is alone in choosing an indoor

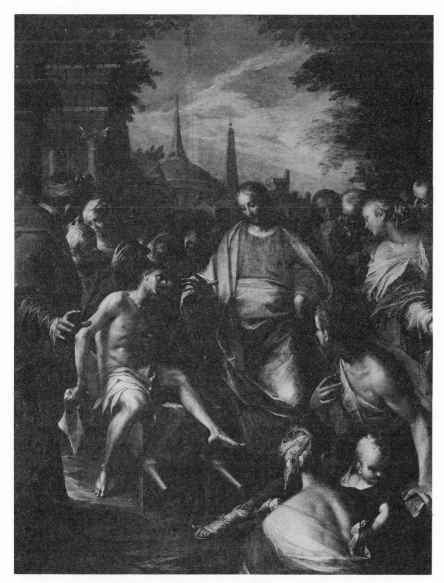

49 Hans von Aachen *Resuscitation of the Young Man of Nain*

scene – the synagogue setting of Mark 1:23 (figure 52) which he uses to press together the agonized bodies and concentrate the sensational scene of Jesus' cures when 'at even, when the sun did set, they brought unto him all that were diseased, and them that were possessed with devils ... And he healed many

50 David Vinckeboons *The Centurion of Capernaum Asks Christ to Heal His Servant*

51 Lucas van Uden *Christ and the Centurion of Capernaum*

52 Jacob Jordaens *Christ Healing the Sick* Drawing

that were sick of divers diseases, and cast out many devils.' (Mark 1:32–4) For all its splendour and success as a visual object (indeed, partly because of them) and for all the excitement of its drama, Jordaens' drawing demonstrates perhaps even more clearly than the earlier pictures the need for Rembrandt to

53 Rembrandt *Baptism of the Ethiopian Eunuch* Etching

redirect Protestant art. Part of the problem is a kind of baroque literalism. Jordaens does not attempt to suggest other meanings for sickness than the literal, physical one. Sickness as spiritual incapacity, *miseria* in its usual Protestant signification, the sickness that requires, as Luther says, 'this physician who has given his body' is simply not his subject. And he is equally indifferent to (or helpless to portray) the Reformation God who lowered himself in love to man. A majestic Christ enthroned, though a fine and moving image, in these terms is a wrong one.

The centrepiece of any discussion of Rembrandt's treatments of blessing and healing must of course be the 'Hundred Guilder Print' (figure 75), but these subjects rich and explicit in their mercy meanings occur frequently in his work, and he was inventive in expanding their variety beyond the easily available Christ Healing the Sick, Christ Healing a Blind Man, or Christ Healing a Sick Person. A similar mood and movement of divine benediction

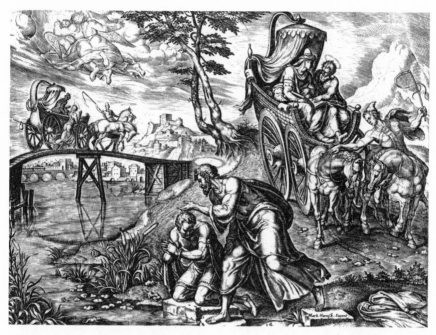

54 Maerten van Heemskerck *Baptism of the Ethiopian Eunuch* Engraving

could be felt in other biblical scenes and clearly drew an informed response from an artist as deeply involved in Reformation attitudes as Rembrandt was. One such subject was the Baptism of the Ethiopian Eunuch which had been treated by such earlier artists as Peter Lastman, Rembrandt's teacher, Jacob Pynas, also a painter with whom Rembrandt may have studied, and Maerten van Heemskerck (figure 54).

The source in Acts 8:26–39 describes an episode in which the apostle Philip meets 'an eunuch of great authority under Candace, queen of the Ethiopians,' who is met by the apostle riding in his chariot reading the prophet Isaiah without Christian understanding. The story is told in the middle of the account of the conversion of Paul and serves in part as a contrasting parable heightening emphasis on Paul's ferocity and refusal to believe, and in part as a minor variation on the theme of conversion and reconciliation. Paul has had opportunities to believe, but would not, and heads towards Damascus 'breathing out threatenings and slaughter against the disciples of the Lord.' The eunuch has had no such opportunities and puzzles over Isaiah as something new and strange.

55 Rembrandt *Peter and John Healing the Cripple at the Gate of the Temple* Etching

Then Philip opened his mouth, and began at the same scripture and preached unto him Jesus. And as they went on *their* way, they came unto a certain water; and the eunuch said, See, *here is* water; what doth hinder me to be baptized? And Philip said, If thou believe with all thine heart, thou mayest. And he ansered and said, I believe that Jesus Christ is the Son of God. And he commanded the chariot to stand still: and they went down both into the water, both Philip and the eunuch; and he baptized him.

Main propositions of the Reformation are easily drawn from the passage: grace is freely given; faith is the *sine qua non* from man's side, both the least and the most that he can offer, and it *precedes* baptism, a point useful in combatting Catholic sacramentalism which, said the reformers, corrupted sacraments into *sacrifices* by which men attempted to *qualify* for salvation.

Rembrandt's treatment in his etching of 1641 (figure 53) compares interestingly with Heemskerck's for its heightening of Reformation values.

Heemskerck has taken the chariot to be a prime datum of the story and allowed his imagination to play with the vehicle itself, which becomes a fantasy car interesting enough to him to picture twice. His narrative approach treats the three separate episodes of Philip running to catch the chariot, Philip and the eunuch in the chariot with a Bible opened across their laps as Philip preaches from it, and finally the baptism itself, which is performed in active, even hurried, movement at the water's edge. Rembrandt's treatment omits none of the persons or objects that belong to the story and, in fact, adds a major figure in the soldier on horseback, evidently a member of the eunuch's guard. The effect is nevertheless one of greater economy and concentration on essential Reformation themes. Even the soldier, aloof and bristling with armament, viewing the proceedings with an eye to worldly plausibility (what we have found Calvin describing as judgment 'according to the feeling of our flesh') contributes a necessary idea. The group isolated at the water is, by vivid contrast, completely turned away from the world of practical affairs and prudential reason in a still scene consistent in its feeling with the blessing and healing of the 'Hundred Guilder Print' and with the forgiving and accepting of Rembrandt's versions of the Prodigal Son. (Indeed, the group of standing apostle, kneeling eunuch, and servant with clothing could be moved almost without change into a Prodigal Son scene.) Baptism was, of course, one of the two sacraments accepted by the Reformation as having scriptural authority, and celebrated as the gift of forgiveness of sin. In Rembrandt's interpretation, consistent with this teaching, it is a form of benediction indistinguishable from blessing and an act of divinely initiated reconciliation.[11]

It is not surprising that Rembrandt should extract the same reconciling value from the subject of Peter and John Healing (Acts 3:1–11) or from Christ and the Woman Taken in Adultery. Despite the power of these works, the extent of his fascination with blessing is more strongly shown in his seeking out blessing subjects in the Old Testament. It is certainly the case, as others have observed, that 'the Old Testament narratives in which an old man blesses his children or his grandsons must have been of particular interest to him.'[12] Jacob Receiving the Blessing of Isaac was one of these in easiest reach, and was already a well-worked vein in Protestant art before Rembrandt – no doubt because the choice of Jacob over Esau (Genesis 25) had stimulated Paul to one of his most ringing declarations on behalf of God's free grace:

It was said unto her [Rebecca, before the birth of her children], The elder shall serve the younger. As it is written, Jacob have I loved, but Esau have I hated. What shall we

56 Rembrandt *Isaac Blessing Jacob* Drawing

57 Rembrandt *Jacob Blessing the Children of Joseph*

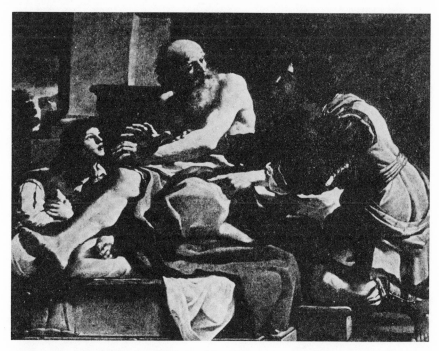

58 Guercino *Jacob Blessing the Sons of Joseph*

say then? *Is there* unrighteousness [injustice] with God? God forbid. For he saith to Moses, I will have mercy on whom I will have mercy, and I will have compassion on whom I will have compassion. So then *it is* not of him that willeth, nor of him that runneth, but of God that showeth mercy ... Therefore hath he mercy on whom he will *have mercy*, and whom he will he hardeneth. (Rom. 9:12–18)[13]

Other Old Testament benedictions such as Jacob Blessing the Sons of Joseph or Jacob Caressing Benjamin could also be found without much seeking, and Rembrandt treated them repeatedly and with feeling. His most ambitious treatment of Jacob's blessing of the sons of Joseph, the recently damaged painting in Cassel (figure 57), is instructive to compare, as the work of a blessing-minded Reformation artist, with the version of Guercino (figure 58), a painter not reached by the same influences.[14] The episode occurs in Genesis 48 and closely parallels Jacob's own blessing by Isaac as an example of the freedom of grace and of God's unexpected choices. Again the younger son is preferred, though this time no subterfuge is involved. Jacob knows what he

59 Rembrandt *The Reconciliation of David and Absalom*

is doing and tells Joseph (who tries to move the old man's right hand from Ephraim's head to Mennaseh's) that the younger son 'shall be greater ... and his seed shall become a multitude of nations.' The scene has an obvious potential for drama in the clash of purposes: ancient Jacob unshakeable as the agent of divine destiny, and Joseph anxious to protect the interests of his

60 Rembrandt *Raguel Welcomes Tobias* Drawing

heir – 'Not so, my father: for this is the first-born ...' Guercino exploits this source of interest in the subject for maximum dramatic excitement. Joseph is shown rushing into the room shouting and seizing his father's arm. Jacob has turned to deal with the interruption, and the older boy raises his head to look at his grandfather with the same question that has agitated Joseph. Rembrandt ignores all of this to concentrate on the act of blessing itself and to make all of the characters join harmoniously in it – a scene which he makes as potent in its suggestions of reconciliation as the Return of the Prodigal Son, and which urges the same Reformation doctrine.

Rembrandt's devotion to the theme of blessing is most striking in his researching of such out-of-the-way subjects as the Reconciliation of David and Absalom (figure 59) and such out-of-the-way sources as the Book of Tobit (figure 60).[15] And he shows that an artist seriously bent on treating blessing can *make* a blessing scene by mere power of interpretation, as occurs in *The Sacrifice of Manoah* or in the remarkable picture of *Jacob Wrestling With the Angel* (Berlin, figure 61), in which the Angel's laying on of hands is almost a caress, and his face expresses a sad and all-comprehending affection for the

61 Rembrandt *Jacob Wrestling with the Angel*

pitiable creature struggling so unnecessarily against him. Man may be blessed, as the Reformers taught, even in the midst of his wilful opposition to God. Still more astonishing in its interpretive originality is Rembrandt's portrayal of the angel blessing in the 1655 etching of the Sacrifice of Abraham (figure 62). The source in Genesis justifies the brutal and sensational treatment of

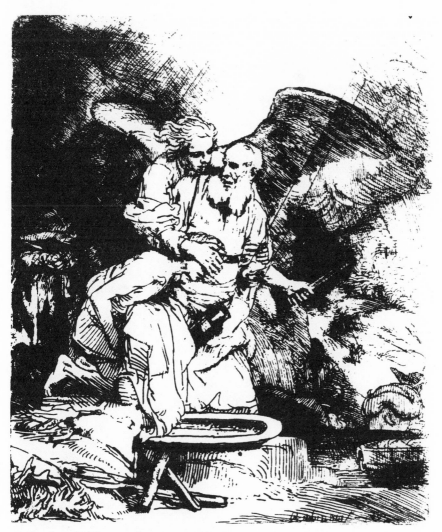

62 Rembrandt *The Sacrifice of Abraham* Etching

Rembrandt's youthful painting of 1635 (figure 63), which shows Isaac bound, his head pushed back roughly for slaughter and the knife dropping from Abraham's hand as the angel rushes in, to call off the sacrifice at the last minute. The later treatment, however, drops the externals of drama and the lurid theology of Genesis. Isaac is a younger child who kneels trustingly.

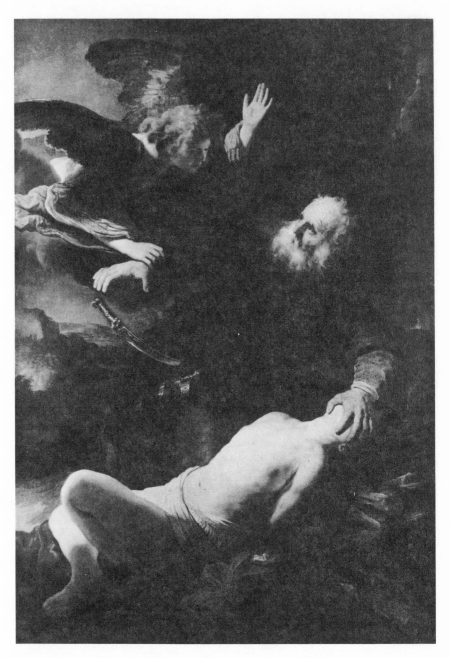

63 Rembrandt *The Angel Stopping Abraham From Sacrificing Isaac*

Abraham is frailer and grief-stricken. The moment shown is still the one in which the angel restrains Abraham, but he does so now with tenderness and a sheltering embrace that includes both father and son beneath extended wings.[16] 'This I do,' says Augustine of writing his *Confessions*, '*under thy wings*; in over great peril, were not my soul subdued unto Thee under thy wings.'[17]

7: Conversion of Paul

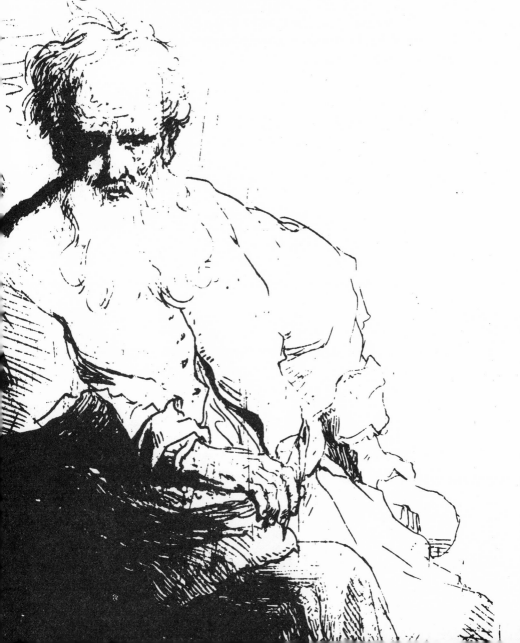

PAUL WAS AN ENORMOUSLY IMPORTANT FIGURE for early Protestantism – the *stilus dei* through whom the true faith had been communicated to the Reformers. Personal identification with him was strong, doubtless because he filled so completely the complex and contradictory requirements of the Protestant hero – one simultaneously exalted and brought low by God's active power and love, a compelling example of 'passive righteousness' by which men were stirred to admiring but, of course, helpless emulation. Paul, in all his shining regeneracy, had not done it for himself; he was a hero under conditions that denied heroism, as his change of name in conversion signified (according to a tradition descending from Augustine). As unregenerate Saul, he bore a hero's name, that of the first king of Israel, and was strenuous in righteous self-assertion, 'breathing out threatenings and slaughter' on behalf of the ancient faith, which was itself devoted to righteous self-assertion. Chosen by God, he is simultaneously humbled, and emerges from conversion (Acts 9) with the name Paul, or Paulus, signifying 'little,' shrinking the claims of self and by implication repudiating heroics. One can speculate that Rembrandt's characteristic figure-type, low and little, responds to this vivid Pauline experience of littleness and insufficiency and its corollary of trusting dependence on God's help in all that matters.

Rembrandt painted himself as Paul. In England, John Donne developed a similar sympathy and never failed to preach on the Feast of the Conversion of St Paul, 'a subject dear to Donne's heart,' as his editor remarks.[1] But Paul was not, of course, merely an individual about whom the generations of reform might develop attitudes of fellow feeling. He was 'annexed' to Protestantism[2] because Protestants found in his message of grace the central and organizing truth of Christian teaching and in his experience as a convert one of the archetypes of essential Christian experience. Paul on the road to Damascus is not merely Paul but Every Protestant Christian. Calvin's commentary on the episode is typical in its leap to the universal and in its use of Paul's experience to argue against Romanist notions that man cooperated in the workings of God's grace:

In this history we have a universal figure of that grace which the Lord showeth forth daily to us all. All men do not set themselves so violently against the gospel; yet, nevertheless, both pride and also rebellion against God are naturally engendered in all men. We are all wicked and cruel naturally; therefore, in that we are turned to God, that cometh to pass by the wonderful and secret power of God contrary to nature. The Papists also ascribe the praise of our turning to God to the grace of God; yet only in

64 Lucas van Leyden *Conversion of St Paul* Engraving

part, because they imagine that we work together. But when as the Lord doth mortify our flesh, he subdueth us and bringeth us under, as he did Paul. Neither is our will one hair readier to obey than was Paul's until such time as the pride of our heart be beaten down, and he have made us not only flexible but also willing to obey and follow. Therefore, such is the beginning of our conversion, that the Lord seeketh us of his own accord, when we wander and go astray, though he be not called and sought; that he changeth the stubborn affections of our heart, to the end he may have us to be apt to be taught.[3]

Changing the stubborn affections of Paul's heart and breaking his and our rebellion was a subject that fostered violent imaginings in painters touched by the Reformation. Lucas van Leyden's handsome pre-Reformation engraving of an interrupted procession of state shows mainly the quiet aftermath, with Paul's fall to earth reduced to a tiny background scene (figure 64). Later artists tended to focus directly on the main event: 'suddenly there shined round about him a light from heaven: And he fell to the earth, and heard a voice saying unto him, Saul, Saul, why persecutest thou me?' (Acts 9:3–4) They found in it matter for horrific excitements. The 'light that shined round about

65 Maerten van Heemskerck *Conversion of Paul* Engraving by Phillip Galle

66 Benjamin Gerritsz. Cuyp *Conversion of Paul*

67 Aelbert Cuyp *Conversion of Paul*

him' is in some pictures turned into sheet lightning. Horses plunge and rear among human bodies strewn as on a battlefield, and landscapes themselves are in tumult (figures 66, 67[4]).

The horses, even Paul's horse, are not mentioned in scripture, but appear very early in treatments of the subject in art and are featured strongly in Renaissance and Reformation versions, illuminating a characteristic confusion of Reformation art to which I have referred repeatedly – the pull and counterpull of an anti-humanist version of Christianity with a humanist aesthetic. To Reformation ways of thinking, the heroic vision of man was an inflated and outrageous form of the humanist vision (as one sees fairly explicitly in Milton's treatment of 'heroic' Satan in *Paradise Lost* and in his distaste for the 'tedious havoc' of heroic subject matter); a *hero* showed the claim to human self-sufficiency carried to a romantic and preposterous extreme. Horses are inevitable accessories of this vision, as are the swords, shields, banners, and other military equipment with which the artists confer heroic grandeur on Paul and his companions.[5] The subject of the Conversion

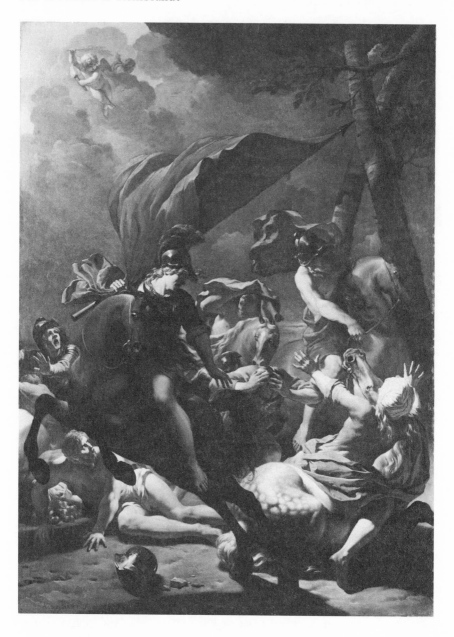

68 Karel Dujardin *Conversion of Paul*

of Paul legitimized a human idealization which the forms and techniques of Renaissance art had been invented to achieve and which continued to be the forms and techniques of Protestant artists somewhat awkwardly committed to a different and conflicting ideology. Thus the Conversion of Paul appears to have offered a kind of heroic holiday to artists whose religious allegiance denied the pretensions of heroism which it was the tendency of their art to confirm.

There was much more to this heroicizing than merely introducing horses and military paraphernalia into the scene. Paul himself is transmogrified. As Réau points out, the hints given in scripture as to Paul's physical appearance make him seem an unlikely subject for heroic treatment. He was 'mean appearing, below average size, bald, runny-eyed, hook-nosed, knock-kneed and possibly afflicted with a nervous disease ' – a striking contrast to 'the heroic Paul of art ... a majestic giant,'[6] often, as in the (Catholic) Dujardin painting, an athletic semi-nude (figure 68).

What justifies heroics in Reformation treatments of Paul's conversion is of course that they are comminatory. The artist can lavish all his art on them (as did Milton on Satan) with the excuse that they are there only to be overthrown, that the essential point of the episode is anti-heroic. But the deepest drift of art itself, as understood and practised by these painters, was humanist. Humanism inhered in the Renaissance origins of Protestant art, which needed nothing more than releasing by such a subject as the Conversion of Paul to show how warmly it could embrace the heroic ideal derided and deplored in the anti-humanist theology that it meant to serve. It would be an exaggeration to say that every Reformation artist contained a Renaissance artist struggling to subvert him, but it is clear that his art was not naturally obedient to his doctrine and that his occasional surrenders to humanist idealizing are digressions from his Reformation message. A similar problem has been found in *Paradise Lost*, where modern criticism has been troubled by a 'split ... between ethic and aesthetic, process and sentiment.'[7]

Of painters responsive in any way to Reformation ideas, Caravaggio found the most original formula for suppressing heroics while giving full play to the amazingness and scope of Paul's comeuppance (figure 69). The horse, prominent among the heroicizing features of most pictures, is prominently unheroic in Caravaggio's *Conversion*. It is an unglamorous piebald painted rump foremost, not plunging in terror, or launched upward with flared nostrils and streaming mane, but slowly picking its way among the discomposed limbs of the fallen Paul, being careful not to step on him. Its

69 Caravaggio *Conversion of St Paul*

70 N. Beatrizet *Conversion of St Paul* Engraving after Michelangelo

bridle is being held by a man with the seamed face of a middle-aged labourer whose expression of mild concern appears to arise from the horse's problem of not stepping on Paul. Both horse and man are quiet, outside observers of the action, which has nothing about it of heroic tumult. Paul himself, though dressed in a generally Roman military style and with the sword that is his attribute by his side, looks more like a sprawling peasant than a vanquished hero.[8]

Caravaggio's reductive literalism could not have attracted Rembrandt as a way of dealing with the heroicizing tendencies of this subject, and no other solution – for a finished work in painting or etching – seems to have come to him.[9] One drawing exists (figure 71)[10] in which he met the problem head on by adapting from Michelangelo's much imitated Vatican fresco of which there would almost certainly have been a copy in the book 'full of the work of Michelangelo Buonarotti' which was listed among Rembrandt's possessions

71 Rembrandt *Conversion of Paul* Drawing

in 1656 when his goods were sold for debt. Kenneth Clark has commented on the rarity of Rembrandt's references to Michelangelo in his work and has suggested that 'Michelangelo's heroic idealization of humanity' would not have been easy for Rembrandt to digest.[11] Inevitably, Michelangelo's is the most heroic Conversion of Paul in the history of the subject (figure 70), and its digestion by Rembrandt is managed only by immense exclusions – of heroic groupings in both heaven and earth, of splended modelling and ambitious composition and, not least significantly, of the horse (figure 71). The drawing is only a sketch, the first motion toward the working out of an idea, and perhaps not at all what Rembrandt would have committed himself to in a final

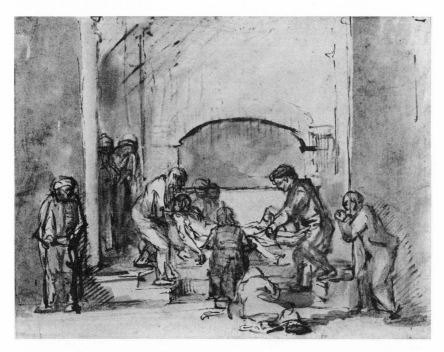

72 Rembrandt *Entombment* Drawing

version. Still, some tendencies are clear. Rembrandt has picked out Paul and
the three figures placed closest to him by Michelangelo as a sufficient cast to
represent the drama and convey the necessary human response to it. They are
expressive without the large gestures of Michelangelo's figures; the body type
is, of course, completely altered, and the quality of feeling. Where Michel-
angelo's Paul is a splendid and vitally responsive patriarch on the model of
his Moses, and the people surrounding him are a race of heavy-muscled
Titans, the Paul of Rembrandt, like his companions, is a small and crumpled
figure inadequate to the grace that has been dropped upon him; staggered,
unresistant, and pathetic, he invites only the tender mercy of a God who,
despite the violence of his corrections, is mercy itself. Perhaps the most
striking single effect of tenderness in Rembrandt's transformation of the scene
comes in his use of the figure that supports the fallen Paul. In Michelangelo's
picture, Paul is caught in the instant of falling with the sudden, grabbing
(though graceful) reflex of the person closest to him. Rembrandt has chosen a

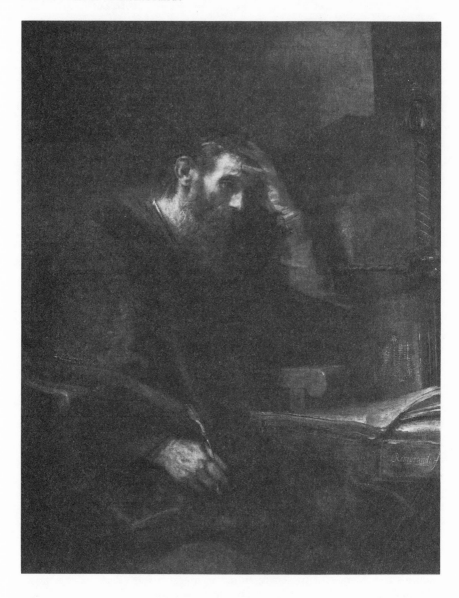

73 Rembrandt *The Apostle Paul at His Desk*

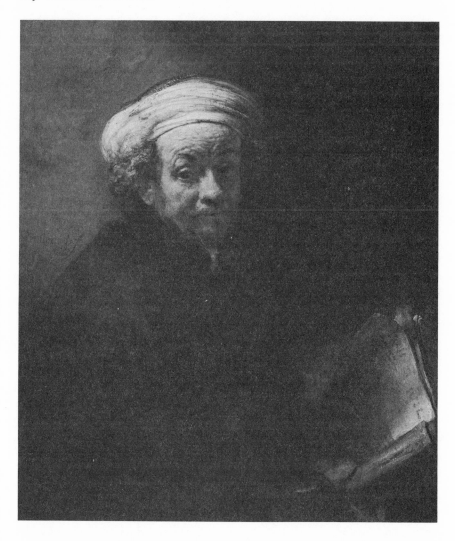

74 Rembrandt *Self-Portrait as the Apostle Paul*

later, quieter moment and has borrowed a traditional motif from the Descent from the Cross. The sagging figure of Paul is supported under the arms in exactly the way the sagging body of Christ is supported in countless Depositions, and with the same tender solicitude. (Rembrandt uses the position in several versions of the Entombment, for instance, figure 72.) It is an allusion to a scene of more exquisite pathos and explicit reconciliation than earlier artists had been imagining on the road to Damascus.

The total of Rembrandt's pictures of Paul in painting, etching, and drawing may number as high as eleven, including the remarkable self-portrait as St Paul which seems to show incontestably that 'Rembrandt identified himself with St. Paul.'[12] But he did not identify as a man of heroic action, or of action at all. Both of the great paintings of St Paul are deeply quiet, even passive. Otto Benesch considered the *Apostle Paul at His Desk* (figure 73) to represent a type of the contemplative life, 'fraught with thought,' and contrasting with the 'life of struggle' represented in the St Bartholomew painting of the same time.[13] This monumental three-quarter length figure of a noble Paul, momentarily abstracted from the task before him to contemplate the great truths of which he writes, is quiet in a grander style than the Paul of the self-portrait who gazes out directly at the viewer, with all of life's humbling experience shared between them (figure 74). Paul at his desk is majestic, while Rembrandt-Paul wears, perhaps, the most vulnerable expression of any of the self-portraits. Over both alike, however, flows a half-light so tender and intense as to suggest that Rembrandt meant to combine the Reformation's evangelical insistence that God is love with the ancient belief that God is light. ('God is light' in John 1:5; and light in Milton's splendid language is 'bright effluence of bright essence increate.') It is a light that is awful with divine presence yet soft with divine affection, thus a main element in the strategy for conveying the notion of forgiveness with which Rembrandt, finally, found means in art to match the peculiar vision of the great Reformers. In that light, it is obvious, the standard imagining of Paul's conversion, 'the heroic Paul of art,' could not be entertained.

8. Rembrandt: Three Crosses

BURCKHARDT'S DEPLORING OF REMBRANDT'S FORMS as 'ugly' is a useful clue that the art of Rembrandt embodies essential values of the Reformation. Its contradiction of Renaissance values would, of course, be visible and objectionable to the great nineteenth-century celebrator of Renaissance life and art, and, indeed, its Reformation message can scarcely be mistaken. Man, as Rembrandt shows us with increasing urgency into his old age, is a creature of tragic limitations, hopelessly inadequate to his own necessities, trapped in a life of frustration and pain, and dependent absolutely on divine mercy for redemption from it. He is a Prodigal Son, errant but forgiven, lost by himself but found by God as in the parable to which Rembrandt so often returned and in which it has been said he saw 'the key parable of humanity and which, ever present in the background of his mind, recurs under various aspects in so many of his works.'[1]

Rembrandt was not, of course, like Michelangelo, a father of the Renaissance, needing to abandon a lifetime's education in classical humanism and ethical Christianity before he could come to the sense of things expressed in the *Rondanini Pietà*. Indeed, it would not be misleading to say that Rembrandt's characteristic vision, from the middle of his career onwards, is that at which Michelangelo arrives at the very end of his life.

Like the figures of the Rondanini Pietà, Rembrandt's people bend under the weight of existence, and it is undoubtedly because old people bend so much more expressively than young that Rembrandt gives so much attention to age – as in the many studies in paint and etching of 'Rembrandt's Mother,' 'Rembrandt's Father,' male and female beggars and tramps, and in the paintings which conclude his long series of self-portraits where he shows himself in advanced senile decay. His preoccupation with the pity of life, its vulnerability and endless painful circumstances, is a primary source of interest even in works whose subjects seem to lack inherent pathos – burgher portraits, for example, and his own youthful self-portraits, in some of which he is foppish in a velvet hat and wears an air of cavalier assurance. But in setting down the features of burgher or fop, Rembrandt seems to say also that all is frail pretence, beneath which is plain unaccommodated man, perilously isolated and exposed.

It has been commonly felt that Rembrandt's vision is tragic, that his people exist 'under sentence of death,'[2] but it is perhaps more important that they exist also with the promise of reprieve and reconciliation. His perspective is one in which the human condition is seen 'under the eye of eternity,' a view which as Protestantism conceives it, diminishes man and his concerns, cor-

rects and admonishes, but above all forgives. Rembrandt forgives his people, or makes them accessible to forgiveness, by subtly changing men and women into children, whose evil and error and delusion seem not to deserve stern condemnation and from whom it is impossible to demand what the God of law and justice would have to demand, the 'doom severe' of 'rigid satisfaction, death for death' initially demanded by Milton's God in *Paradise Lost*.[3] Rembrandt's human figures are made small relative to their surroundings, their outlines are simplified and rounded, and their proportions (especially their legs) shortened: they stand low in space which is slightly too large for them.

The happiest corroboration for this approach to Rembrandt's figures comes from Stephen Jay Gould, a palaeontologist and writer on evolutionary theory whose most recent book pays in one of its chapters 'A Biological Homage to Mickey Mouse.' The fifty-year history of the cartoon character, according to Gould, is a history of progressive 'softening': from beginnings as a rascal and trickster he became increasingly lovable and a model of good behaviour. With the change of personality came a change of appearance: the Mickey who is intended to be loved is a much more childlike figure than reprobate Mickey. He is given shorter and pudgier legs. The Disney artists 'have lowered his pants line and covered his legs with a baggy outfit. His arms and legs also thickened substantially – and acquired joints for a floppier appearance.' His head grew larger relative to his body, and certain childlike facial features were exaggerated. Gould notes that these changes in the drawing of Mickey and the intent behind them are consistent with the well-known suggestion of Konrad Lorenz that humans use differences between adult and childlike forms as 'behavioural cues,' that there are 'innate releasing mechanisms' in us causing us to respond with an involuntary rush of tenderness and urge to nurture when we see childlike forms. Lorenz's description of such forms fits Mickey Mouse well. Parts of his description also fit Rembrandt's figures; 'a relatively large head, short and thick extremities, a springy elastic consistency, and clumsy movement.' Rembrandt seems to have taken for granted, with perhaps unavoidable anthropomorphism, that what would stimulate tenderness in humans would do the same in God – or that anthropomorphism would operate so strongly in us as to produce the necessary transference.[4]

Men and women thus transformed into children are visited in Rembrandt's scenes from the New Testament by a Christ who expresses only compassion – a far more 'reconciling' figure than most Renaissance Christs. (Compare the

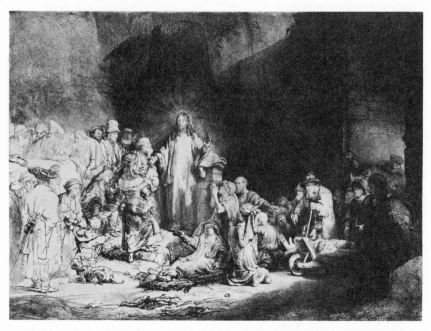

75 Rembrandt *Jesus Healing the Sick* ('The Hundred Guilder Print') Etching

heroic Christ of Michelangelo's *Last Judgment.*) The 'Hundred Guilder Print' is a famous representative of the type (figure 75). The subject is 'Christ with the sick around him, receiving little children.' Christ himself, though small and plain in dress and feature – the majesty and greatness of God humbling itself in love to man – stands in a commanding central position at the crest of a low wave of broken and suffering human figures who enter from the darkness at the right of the scene to be illuminated with the light which Christ sheds over all, including, at the far left, a fat, foolishly elegant figure with large hat and walking stick, who stands conspicuously with his back to the viewer in a position suggesting indifference to the proceedings and imbecile self-content. The urgent and deeply felt message of God's infinite and self-giving *misericordia* for man's dire *miseria* in all its forms is perhaps nowhere in the whole range of Protestant expression stated with greater force and feeling.

Rembrandt's is not a force of eloquence. Visser 't Hooft has said that Rembrandt 'heard the words, "My grace is sufficient for thee," '⁵ and it seems clear that one implication of the words to which he was sensitive was that his

practice as a religious artist should be such as to avoid ostentation and artistic self-display. The dilemma is similar to that of the English poet George Herbert who was equally caught in the contradiction between Reformation theology and the demands of art; for Herbert was compelled by overwhelming conviction to write poems which would witness to the truth of grace, and perplexed to find means in poetry which would not be contaminated with self and hence, by intolerable implication, a denial of the sufficiency of the grace he meant to affirm. If it had been possible, Herbert would have written poems which 'plainly said, My God, My King' and nothing more. A way of dealing with this problem was his celebrated 'plain style' which, as completely as verbal genius could, renounced eloquence. He was on guard against the tendency to 'burnish, sprout, and swell / Curling with metaphors a plain intention.' There was, inevitably, a failure of completeness in Herbert's attempt to subordinate self and art to the idea of divine all-sufficiency. On the contrary, his skill and his delight in exercising it are sufficiently evident to raise the issue of virtuosity: he 'outpoeted' most of his contemporaries just as Rembrandt, according to the authors of a widely used survey of Christian art, 'outpainted' his.[6] The direction of Herbert's effort is obvious, nonetheless, and, rich with implications for the understanding of Rembrandt. He avoids splendour in all its forms; his language is simple – at times startlingly childlike; he avoids the excesses of ornamentation of the Elizabethan poets (though his austerity is good-humoured) and the excesses of wit of the so-called 'metaphysicals;' his tone is quiet and uneccentric, unlike the brilliant and outrageous Donne with whom he is standardly compared; his imagery and ideas are almost exclusively biblical.

Rembrandt's austerities involve similar choices and an equal effort to control virtuosity. His 'brownness,' for example, deplored by the generation of Gainsborough and Reynolds, is an obvious device for subduing colouristic brilliance, and the need to be plain may also in part explain what drew him so strongly to etching, perhaps the weakest of pictorial arts from the standpoint of sensuous 'ingratiation.' His 'realism' in handling forms, whether drawn, etched, or painted, is essentially astringent and reductive, simplifying and abstracting down to barest essentials, in vivid contrast to the caressingly detailed tactility of his great Catholic contemporary, Rubens. Such determined modesty of means had been implied by Reformation doctrine from the first, though the point was slow to be grasped by artists, and it was left for the greatest of them to make the greatest renunciation. And yet, in turning aside from the rich and humanly assertive art of the Renaissance tradition to find

a form-language capable of conveying the astonishing anti-humanist message of the Reformation, Rembrandt renounced one empire of art only to seize another still more powerful in its human evocations.

In choosing among mercy motifs Rembrandt made most use of episodes from the life of Christ: preaching, healing, the Passion, the Entombment, the Feast of Emmaus, the Raising of Lazarus, the Woman Taken in Adultery. The five states of *The Three Crosses* belong to the decade of the 1650s, during which he made repeated returns to the Passion, the subject densest of all with reconciling implications – in fact, according to Reformation teaching, the unique reconciling act, performed by God in mercy to man, the essential and literal reconciliation for which the others surveyed in this study can be considered metaphors. The early states of *The Three Crosses*[7] follow the account of Matthew 27 with some particularity:

And they crucified him, and parted his garments ... And sitting down they watched him there; And set up over his head his accusation written, THIS IS JESUS THE KING OF THE JEWS. Then were two thieves crucified with him, one on the right hand, and another on the left. And they that passed by reviled him ... Likewise also the chief priests mocking him, with the scribes and elders, said, He saved others; himself he cannot save. If he be the King of Israel, let him now come down from the cross, and we will believe him. He trusted in God; let him deliver him now, if he will have him: for he said, I am the son of God. The thieves also which were crucified with him, cast the same in his teeth.

Now from the sixth hour there was a darkness over all the land unto the ninth hour. And about the ninth hour Jesus cried in a loud voice, saying, Eli, Eli, lama sabachthani? that is to say, My God, my God, why hast thou forsaken me? Jesus, when he had cried aloud again with a loud voice, yielded up the ghost. And behold, the veil of the temple was rent in twain from the top to the bottom; and the earth did quake, and the rocks rent ... Now when the centurion, and they that were with him, watching Jesus, saw the earthquake, and those things that were done, they feared greatly, saying, Truly this was the Son of God. And many women were there beholding afar off, which followed Jesus from Galilee ... (Matthew 27:35–6).

The scene in Rembrandt's first version (states 1–3) is crowded and miscellaneous and surrounded by the darkness which fell at the sixth hour (figure 76). The three figures on their crosses loom above a busy crowd of soldiers, mourners, and 'them that stood by.' There are signs of hurried leaving. The two figures scuttling away in the foreground may be making

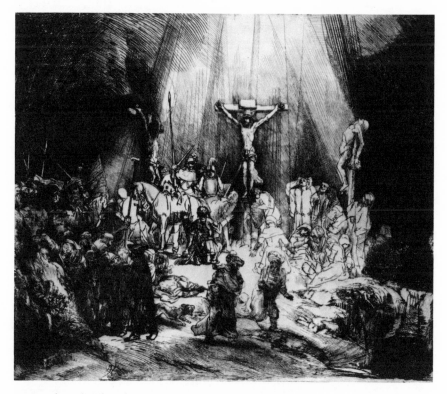

76 Rembrandt *The Three Crosses* Etching, first State

haste because of the barking dog or because of the supernatural upheavals in the landscape. A group to the left moves away more sedately, turning its back on the central drama of the centurion recognizing God. Indeed, Rembrandt isolates the centurion both from his men, who go on about their soldiers' business, and also from the group of Christ's people, who are too intent upon their sorrows to notice. The necessary Reformation point emerges: the grace which produces faith singles out its man without respect to righteousness. The women huddled together, the despairing St John with his hands raised behind them, the figure prostrated by grief at the centurion's back are all, though belonging to the party of the faithful, withdrawn from the essential action. Their grief is for the loss of their human friend – Christ as man – whereas the centurion, shocked into adoration, is seeing God. The wind of mercy, blowing only where it listeth, improbably picks from among the jeering executioners.

The conception is not sentimental. There is no prettiness in any of the figures, including Christ's, and a deliberate irony seems to be at work in the isolation of the central drama, which is denied maximum emotional resonance by the surrounding inconsequentiality. The world will go on in its triviality, brutality, foolishness, wickedness, and grief, essentially undisturbed by the overwhelming contact of the individual with the infinite. (The light-drenched figure leading the horse is an almost comic example: despite the loss of his features in the third state, he conveys the impression of total absorption with the horse.) The public nature of the place and occasion notwithstanding, the centurion's experience according to a characteristic Reformation insistence, is essentially a private one.

The figure of the centurion is the most conspicuous example of the type of the stumpy childlike figure that I have claimed Rembrandt designed to express human helplessness and the need for grace.[8] To be sure, the figure of Christ is no grander or more humanly authoritative, yet it belongs to the bestower of mercy, rather than a receiver. Christ's lack of grandeur, however, is equally dictated by the conception of *sola gratia* justification. Visser 't Hooft has pointed out that Rembrandt's Christ figures express the complete abasement of God,[9] and this is, of course, a necessity of a religious art committed to showing the extent of the divine willingness to accommodate mankind. As it is by God's self-humbling initiative that the gulf which separates him from man is closed, God will be shown humbled.

This is the meaning of the incarnation according to the Reformers, as Visser 't Hooft again shows with a well-chosen quotation from Luther:

Luther makes an unambiguous distinction between a theology of glory and the true theology of the cross. The theology of glory, he says, 'prefers works to suffering, glory to the cross, power to weakness, wisdom to foolishness, and in one word evil to good.' But the theology of the cross knows that 'it is not enough for anybody nor does it help him that he recognizes God in his glory and majesty, unless he recognizes him in the abasement and ignominy of the cross.'[10]

'In analogy,' says Visser 't Hooft, 'we may describe Rembrandt's style as "painting of the cross."' We may, indeed, and conclude that an important identification has been made. Visser 't Hooft does not go on to suggest, however – indeed he refuses to – that such 'painting of the cross' is Reformation painting. His view is rather that Rembrandt's art is simply biblical, that is, based on a right reading of what the Bible unmistakably says:

Rembrandt 'interpreted the gospel in the light only of this very gospel,'[11] without the aid of 'systems' or theologies.[12] While one can scarcely take issue with the view that Rembrandt 'was a painter, not a theologian,'[13] or even, for that matter, a student or an amateur of theology, it seems clear enough that his religious ideas are those of his time and country, hence founded in the Reformation and not simply the result of submitting his unprejudiced intelligence to the evidence of the biblical text. Visser 't Hooft's resistance to the possibility that Rembrandt's biblical interpretations were Reformation-conditioned wavers once or twice (as in the suggestion that 'we might even draw the conclusion that Rembrandt's interest in circumcision was a typical Reformation attitude'[14]), but in the main he holds firmly to the line that Rembrandt was simply a faithful and perceptive reader of the Bible's essential message. Visser 't Hooft's is not, evidently, the position of a scholar working in a historical field (who might hesitate to claim to know what the essential message of the Bible is), but rather that of a Dutch Protestant in whom the Reformation still lives and for whom, as for the Reformers, the scripture is the 'cradle wherein Christ is laid.' Having the convictions of the Reformation itself is, of course, a special advantage to a Rembrandt interpreter (something like a scholastic philosopher reading Dante) which Visser 't Hooft has used fully. Believing what Rembrandt believed, he knows Rembrandt's religion from the inside and describes it with an insider's authority. The spiritual insider's disadvantage, however, is that he cannot entertain the notion that his perfect truth, the subject of his *faith*, is in any important sense historically conditioned or the product of a way of looking at things that is characteristic of a particular time or place. Visser 't Hooft flatters and protects his own faith then, even while somewhat lefthandedly vindicating the Reformation, when he insists that Rembrandt's religious attitudes are simply the result of an attentive taking in of what the Bible plainly says.[15] The true faith has always been there to be found, and it is the separate but equal glory of Rembrandt and the Reformation that both found it.[16]

The changes made in the fourth state of the *Three Crosses* are such as to cast doubt on Rembrandt's biblical simplicity (figure 77). The biblical tale, for one thing, is no longer told: the figures of the mourners have become indistinguishable, though the darkness contains huddled misery; other actors, such as the chief priests, scribes, and elders, are entirely missing; one of the crucified thieves has been absorbed into the darkness (Three Crosses in effect becoming Two Crosses), a striking departure from the circumstantial following of the gospel story attempted in the original plate where there were 'two thieves

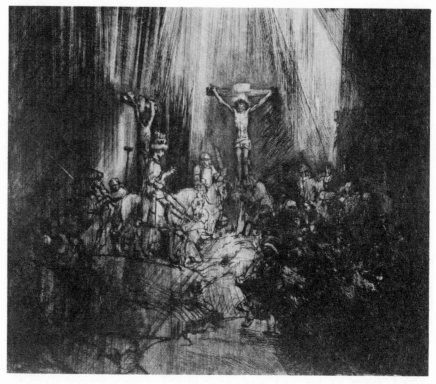

77 Rembrandt *The Three Crosses* Etching, fourth State

crucified with him, one on the right hand and another on the left.' Most remarkable, however, is the elimination of the centurion (a figure that may be the centurion is vestigially there, but changed in position and mostly erased). Taking his place at the dramatic centre of the picture is the rigid and impervious horseman, backed by another horseman less prominent, but drawn with even more brutal simplicity. It is an important clue, I believe, to Rembrandt's intention in the reworking of the plate that he has adapted his horseman from a quattrocento medal, Pisanello's head of Gian Francesco Gonzaga,[17] and kept the archaic half-abstract quality of the original. Consistent with other changes in the plate, the horseman represents a major change of artistic mode – from busy to simple, active to static, narrative to symbol.

He is not designed, in Rembrandt's version any more than in Pisanello's, to be a participating character in a human action. Kenneth Clark finds the

chinless face in profile 'human and touching in its feeling of resignation,'[18] but surely this is to look for pathos where none exists. The horseman is as dissociated as an automaton (or a figure in allegory) from the terrible event before him, or beside him, and this dissociation is in fact what he seems intended, as a symbol, to express. Unlike the centurion who interacts with Christ in a sudden and loving eliciting of faith, horse and rider move through the scene of the passion without a sign of recognition or response. The transformation of the picture is astonishing and original and, at first glance, dangerously free in its handling of sacred matters. For the cross and the sacrifice of Christ *mean* reconciliation in Christian symbolism of all periods – but with a special literal force, to the Reformation, with its insistence on the total powerlessness of men to promote reconciliation from their side. Rembrandt has chosen to suppress this meaning of the subject in his revision, emptying the scene of its traditional meanings of union and replacing them with a message of disunion. His purpose is not blasphemous, but it is not, either, the purpose of a simple interpreter of the gospel by its own light. Behind his purpose lies a definite Reformation understanding of the conditions of reconciliation. The coming together of man and God through the action of divine mercy is a consummation imagined with greater fervour in Reformation religion largely because of its stronger conviction of man's sinful separateness. In fact *sinful* and *separate* are very nearly indistinguishable ideas in Reformation theology and together comprehend the predicament of mankind as a whole; for what occurred at the fall was that man broke union to separate himself from God. Disobedience was wilful opposition, making us 'enemies to God, and opposed to his righteousness in every affection of our heart,' creators of the 'distance between the spiritual glory of the speech of God and the abominable filth of our flesh.'[19] The villain is our depraved human will, which, until liberated by divine grace, is punished by being allowed to go its own way, independent of the will of God, a condition which the Reformers described as a 'bondage' to world and self. 'Freedom,' the Christian Liberty celebrated by Luther, is the willing obedience of those whose hearts have been changed by grace and whose wills have turned from self to God. Rembrandt's rigidly self-enclosed horseman, turned the opposite way and ignoring the offer of reconciliation from the cross, seems a clear enough attempt to illustrate a predicament regarded by the Reformation as identical with the human condition. The characteristic and essentially human response of man is to reject his true good: 'But to Israel he saith, All day long I have stretched forth my hands unto a disobedient and gainsaying people.' (Romans 10:21)[20]

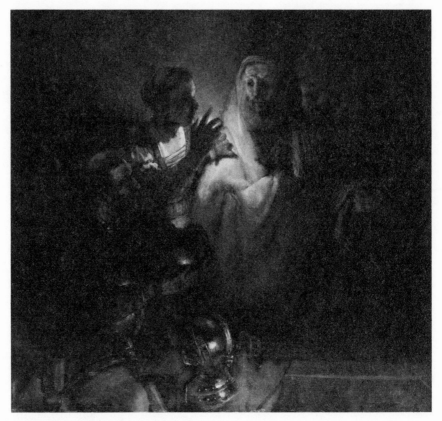

78 Rembrandt *The Apostle Peter Denying Christ*

That this response is *unfree* is a proposition of theology which Rembrandt obviously understood and used forcefully in two of the great late paintings. *The Apostle Peter Denying Christ* (figure 78), shows the terrible perplexity of the apostle, a spirit righteous to the limit of human capacity, but unable to make the self-renunciation that he knows his faith requires, that he has committed himself to making ('Lord, I am ready to go with thee, both into prison, and to death' Luke 22:33) and, to judge from the earnest and troubled expression given him in Rembrandt's painting, *wants* to make. It is a torment of the intolerable ambivalences described by Augustine:

For the will commandeth that there be a will; not another but itself. But it doth not command entirely, therefore what it commandeth, is not. For were the will entire, it

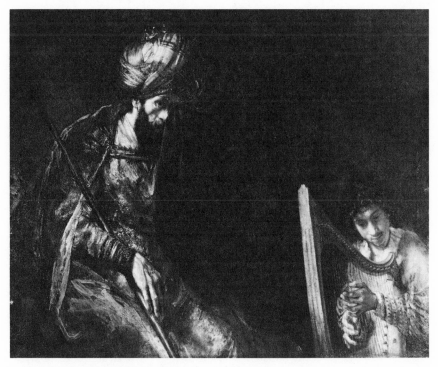

79 Rembrandt *David Playing the Harp Before Saul*

would not even command it to be, because it would already be. It is therefore no monstrousness partly to will partly to nill, but a disease of the mind, that it doth not wholly rise, by truth up-borne, borne down by custom. And therefore are there two wills, for that one of them is not entire: and what the one lacketh, the other hath.[21]

Saul's unfreedom, in the *Saul and David* of the Hague (figure 79), is of a different kind, but equally ambivalent, for 'the Spirit of the Lord departed from Saul, and an evil spirit from the Lord troubled him.' (1 Samuel 16:14) Saul's servants, who tell him to find a harpist to play to him and he shall 'be well,' evidently understood his affliction to be in the nature of an illness, and Rembrandt bases his interpretation on this and other hints in Samuel that Saul is mentally ill. He has 'rejected the word of the Lord,' according to Samuel, without quite knowing it or meaning to (but by making the error that the Reformation well understood of offering *sacrifice* in place of *obedience*; 1 Samuel 15:23) and had in fact begged, 'pardon my sin, and turn again with me,

that I may worship the Lord.' As Rembrandt shows him listening to David, Saul is again divided between acceptance and rejection. He is moved by David's music toward reconciliation and softens so far as to shed tears, but the spear remains in his hand which in a violent change of mood he will fling at David with intent 'even to smite him to the wall.' Neurotic compulsion, then, is one of the ways in which the bondage of the will can be imagined. Another is the frighteningly mechanical horseman of the *Three Crosses* (fourth state).

That such imagining is theological seems sufficiently obvious. But it need not be the theology of the learned; in fact the idea of a learned Rembrandt is objectionable in the light of a well-founded tradition of three hundred years. I suggest only that Rembrandt knew as much about the bondage of the will as an intelligent layman living in a theologically sensitive place and time would have been fairly certain to know. He would not have read treatises. He might have forgotten, though I doubt it, that the bondage of the will was the point at issue in the historic debate between his countryman Erasmus and Luther. He would, nevertheless, have had plentiful and insistent sources for the idea in popular religion – in sermons, tracts, catechisms, and in the pious reflections of pious people who knew (universally in Protestant countries in Rembrandt's time) that the will's bondage was the cause of our disobedience and alienation from God, and that grace alone could make it free. This is not – it needs insisting to some considerable authorities – the situation of an artist 'alone with his experience of human life ... and with no other guidance than the words of the Bible.'[22]

Notes

All references to the Bible are to the King James 1611 version. In a few instances, some secondary material in other languages has been translated by the author into English. Catalogue references to the works of Rembrandt are as follows: Etchings are identified by 'B', according to the standard listings in A. Bartsch, *Catalogue raisonné de toutes les estampes qui forment l'œuvre de Rembrandt, et ceux de ses principaux imitateurs* (Vienna 1797); the most recent scholarly edition is Christopher White and Karel P. Boon *Rembrandt's Etchings* 2 vols (New York 1969). The 'Benesch' number refers to Otto Benesch *The Drawings of Rembrandt* ed Eva Benesch 6 vols (London 1973). 'Bredius' (or 'Br') refers to A. Bredius *Rembrandt: The Complete Edition of the Paintings* rev H. Gerson (London 1969).

CHAPTER I

1 Seymour Slive 'Notes on the relationship of Protestantism to seventeenth-century Dutch painting,' *Art Quarterly* 19 (1956) 3
2 Two works which are not piecemeal and which I have consulted at several points are F. Buchholz *Protestantismus und Kunst* (Leipzig 1928) and Léon Wencelius *Calvin et Rembrandt* (Paris 1937). Buchholz' refusal to generalize about Protestantism illustrates one of the inhibiting difficulties of the subject. 'Protestantism "as such" is not conceivable for the historian. He is always dealing only with particular denominations, which themselves again are limited within a time frame. To write on the position of Protestantism "as such" on art would mean to publish a book of blank white pages' (21). Protestantism in the Reformation can, however, be crudely distinguished from Catholicism on the basis of its root idea – that men are justified, ultimately *saved*, through the action of divine grace which operates in independence of human merit and good works. The influence of this idea on Protestant artists I take to be a question of substance to which rationally acceptable answers can be found. See also 'Refor-

mation' in the dictionary *Die Religion in Geschichte und Gegenwart* (1961) v cols 858ff.

3 Jakob Rosenberg *Rembrandt: Life and Work* 3rd ed (New York 1968) 179. The statement seems to describe a prima facie impossibility. Protestant piety and Protestant ideas were pervasive in Protestant countries and were inescapably absorbed and put to use by Protestant artists. Wencelius does not exaggerate when he speaks of the 'Calvinisme qui est à la base de la civilisation néerlandaise.' (*Calvin et Rembrandt* 9)

4 See, for example, Charles de Tolnay *Michelangelo, v: The Final Period* (Princeton 1960) and Walter Friedlaender *Caravaggio Studies* (Princeton 1955).

5 This is the view disputed in G.G. Coulton's *Art and the Reformation* 2nd ed (Cambridge 1953), an energetic attempt to argue that the Reformation was not simply a disaster for the arts.

6 See Charles Garside jr *Zwingli and the Arts* (New Haven 1966).

7 *The Journal of William Dowsing* ed C.H. Evelyn White (Ipswich 1835) 16

8 Emile Mâle *L'Art religieux de la fin du xvie siècle* 2nd ed (Paris 1931). The artistic response to the doctrine of grace was not, of course, limited to pictorial art. I have argued in *The Poetry of Grace* (New Haven 1970) that the Protestant system of salvation provided themes and a characteristic structure for the great religious poetry of the English seventeenth century. That argument has been adopted and extended by Barbara Lewalski in her *Protestant Poetics* (Princeton 1979).

9 *The Sermons of John Donne* ed Evelyn M. Simpson and George R. Potter (Berkeley and Los Angeles 1962) I 255

10 This conventional term is not easily avoided in describing the interests and emphases of Reformation theology, though it has aroused Catholic objection on the ground that Augustinian influence was too vigorous throughout the Middle Ages to need reviving by Reformation Protestants.

11 John Calvin *Commentaries on the Epistle of Paul the Apostle to the Romans* trans and ed John Owen (Edinburgh 1849; rpt Grand Rapids 1948) 261

12 Ibid 215

13 Ibid

14 Martin Luther *A Commentary on St. Paul's Epistle to the Galations* rev and ed on the basis of the Middleton edition by Philip S. Watson (London 1956) 23

15 *The Dutch Annotations upon the Whole Bible ... as ... Appointed by the Synod of Dort, 1618, and Published by Authority 1637* trans Theodore Haak (London 1657). Reference to commentaries is by chapter and verse of the Bible. Punctuation has been slightly modernized.

16 *Confessions* trans E.B. Pusey (London nd) 173

17 Ibid 207

18 Luther *A Commentary on ... Galatians* 229

19 Ibid 272

20 Luther's references to Aristotle are collected and discussed in B.A. Gerrish *Grace and Reason: A Study in the Theology of Luther* (Oxford 1960) 1–2. Aristotle's influence is vicious, according to Luther, only in theology. His natural philosophy is useful, his *Ethics* admirable, so long as not 'mixed up with the theology of grace and salvation.' Rembrandt does him honour in *Aristotle Contemplating the Bust of Homer*. J.A. Emmens comments that Aristotle became the 'official' philosopher of Dutch Calvinism; *Rembrandt en de Regels van de Kunst* (Utrecht 1968).

21 *Luther's Works* XII *Psalms* ed Jaroslav Pelikan (St Louis 1955) 324–5

22 *Luther's Works* XXVI *Lectures on Galatians* ed Jaroslav Pelikan (St Louis 1962) 35

23 *Institutes of the Christian Religion* 2.4.1 ed John T. McNeill and trans Ford Lewis Battles (Philadelphia 1960) 310

24 *Commentary on the Gospel According to John* I trans William Pringle (Edinburgh 1847; rpt Grand Rapids 1949) 45

25 *Institutes* 3.1.3. ed McNeill 541

26 Jeremiah Bastingius *An Exposition or Commentary upon the Catechism of the Christian Religion Which is Taught in the Scholes and Churches both of the Lowe Countries and of the Dominions of the Countie Palatine* (Cambridge 1593) 72

27 Ibid 37

28 Rensselaer W. Lee *Ut Pictura Poesis* (New York 1967)

29 Benedetto da Mantova 'The benefit of Christ's death' *Aonio Paleario and His Friends* ed William M. Blackburn (Philadelphia 1866) 15–16 and 29. Echoes of St Paul come through Benedetto more strongly than do those of Augustine, but the points are often interchangeable. It is Paul, for example, whom he quotes against the law: 'And yet, whatsoever I have gained by it [the law] I have accounted it in all respects to be but loss, for the love of Christ. And especially I esteem all things to be loss for the excellent knowledge of Jesus Christ my Lord; for whom I count all things to be loss, and deem them but as dung, so I may win Christ, and be found in him, not having mine own righteousness which is of the law, but the righteousness which is by the faith of Jesus Christ, which righteousness is given by God. I mean the righteousness of faith, that I may come to the knowledge of Jesus Christ.' (*ibid*) Although the voice is that of Paul in Philippians 3:6–10, it could as well be Augustine, and more than one such passage ends 'as Austin also affirmeth.'

Other disciples of Valdés, some of whom may have practised their discipleship without personal contact, include the famous Piermartire Vermigli (Peter Martyr to Englishmen), Pierpaolo Vergerio, and Celio Secundo Curione, who were later conspicuous among the evangelical exiles. The movement appears to have flourished with the support of powerful lay patrons and to have had adherents in all branches and ranks of the clergy. The latter, at least, fully

understood the tendency of their teaching. Fra Giulio della Rovere, for example, an early victim of the Inquisition, had preached at Tortona, Bologna, and Trieste, 'defending the doctrine of justification by faith with the authority of St. Augustine and of the canons of the synod of Cologne;' Frederick C. Church *The Italian Reformers, 1534–1564* (New York 1932) 59. For detailed accounts of the movement see Church's study; Pierre Janelle *The Catholic Reformation* (Milwaukee 1949); G.W. Searle *The Counter Reformation* (London 1974).

30 Charles Holroyd *Michelangelo Buonarroti, with Translations of the Life of the Master by His Scholar Ascanio Condivi, and Three Dialogues from the Portuguese by Francesco Hollanda* 2nd ed (London 1911). Francesco's conversations may be reasonably factual or entirely made-up, there is really no way of ascertaining. It is an obstacle to literal belief, however, that the imaginary dialogue was a literary form in use in Renaissance Italy.

31 *Carteggio di Vittoria Colonna* quoted by Tolnay v 55

32 Tolnay v 55

33 *Complete Poems and Selected Letters of Michelangelo* trans Creighton Gilbert (New York 1963) 161

34 Mâle considers that these features of the painting contain its essential meaning as a work 'où souffle déjà l'esprit de la Contre-Reforme,' explicitly rejecting the Reformation's *sola fide* doctrine (*L'Art religieux*, 87). Such an interpretation emphasizes orthodox details to the neglect of the heterodox overall conception, which, however, is not so aggressively heterodox as to exclude all the traditional imagery of a Church to which Michelangelo, despite the attractiveness of the new doctrines, obviously remained loyal.

35 Anthony Blunt *Artistic Theory in Italy, 1460–1600* (Oxford 1940) 65

36 Tolnay v 58. I have drawn heavily on Tolnay in my discussion of the painting, only omitting his comments on the role of 'Fate' and 'Fortune,' which seem to confuse the statement of the painting concerning the sources of grace and the objects of faith. Tolnay is more careful than I have been to insist that the religious attitudes expressed in *The Last Judgment* were those of the 'Italian Reformation,' as distinct from Protestantism. I have preferred, at this and other points, to consider Reform as essentially a single movement, unified in its insistence on the doctrine of salvation by grace alone.

37 *The Art and Thought of Michelangelo* (New York 1964) 81

38 K. Lang-Fuhse *Dürers Schriftlicher Nachlass* (Halle 1893) 19–20

CHAPTER 2

1 John Calvin *Commentary on a Harmony of the Evangelists, Matthew, Mark and Luke* trans William Pringle (Edinburgh 1845; rpt Grand Rapids 1949) 1 398–9

2 The Reformation significance of the subject and some features of van Hemessen's

handling of it is discussed in Grace A.H. Vlam 'The calling of Saint Matthew in sixteenth-century Flemish painting' *Art Bulletin* 59 (1977) 561–70.

3 Calvin *Commentary on a Harmony* I 399

4 'To the Christian nobility of the German nation' *Luther's Works* XLIV *The Christian in Society* I ed James Atkinson (Philadelphia 1966) 169

5 Charles H. George and Catherine George *The Protestant Mind of the English Reformation* (Princeton 1961) 34

6 *Commentary on the Book of the Prophet Isaiah* trans William Pringle (Edinburgh 1852; rpt Grand Rapids 1948) III 198

7 Aquinas made use of this concept, but subordinated it to grace, maintaining that man is not independently capable of a good intention and therefore can acquire no merit apart from grace; *Summa theologica* 2.1.114.2.

8 Jeremiah Bastingius *An Exposition or Commentary upon the Catechism of the Christian Religion Which is Taught in the Scholes and Churches both of the Lowe Countries and of the Dominions of the Countie Palatine* (Cambridge 1593) 72

9 Hemessen worked in Antwerp until 1550, when he moved to Haarlem, evidently for religious reasons. See Simone Bergmans 'Le problème Jan van Hemessen, monogrammiste de Brunswick. Le collaborateur de Jan van Hemessen. L'identité du monogrammiste '*Revue Belge d'archéologie et d'histoire de l'art* 24 (1955) 133–57; J. Snyder 'The parable of the unmerciful servant painted by Jan van Hemessen' *University of Michigan Museum Art Bulletin* I (1965) 3–13. The Munich Hemessen was less 'doctrinal' in its original version, which was a money-changer scene. On the alterations and additions see *Deutsche und Niederlandische Malerei zwischen Renaissance und Barock* Alte Pinakothek Katalog (Munich 1963) I 28–9.

10 *Caravaggio Studies* 117–35

11 Ibid

12 Frank Gavin 'The medieval and modern Roman conceptions of grace' *The Doctrine of Grace* ed W.T. Whitely (London, 1932) 162

13 Friedlaender *Caravaggio Studies* 252

14 Ibid 235

15 Ibid 247

16 Friedlaender prints the whole of Sandrart's 'Life' in *Caravaggio Studies* 261–6.

17 Louis Réau *Iconographie de l'art chrétien* III (Paris 1959) 930. Réau fails to allow for the full range of Protestant interests when he complains of the abuse of this subject by sixteenth-century 'realists' who were drawn to it only for its genre possibilities – 'un prétexte pour peindre une boutique de changeur.'

18 *The Reformation Writings of Martin Luther* II *The Spirit of the Protestant Reformation* trans and ed Bertram Lee Woolf (London 1956) 291

19 *Commentary on St. Paul's Epistle to the Galatians* 501

20 In fact it is an example of *portrait historié*. See Rose Wishnevsky *Studien zum 'Portrait Historié' in den Niederlanden* (Munich 1967).

CHAPTER 3

1 *Iconography of Christian Art* I trans Janet Seligman (Greenwich Conn. 1971)
 186
2 The traditional Northern iconographic scheme for the Raising of Lazarus has
 Lazarus rising out of a grave-like tomb. The traditional iconography of the sub-
 ject is summarized in the exhibition catalogue of the Aartsbisschoppelijk Mu-
 seum, Utrecht *Het Wonder* (1962) 11–26.
3 *Luther's Works* LI *Sermons* I ed and trans by John W. Doberstein (Philadel-
 phia 1959) 44–8
4 The order of these works and the direction of influence has been disputed. F.
 Saxl 'Rembrandt und Italien' *Oud Holland* 41 (1923–24) 145ff argues that Rem-
 brandt copied from Lievens. This view is followed by, *inter alios*, C. White
 Rembrandt as an Etcher (University Park and London 1969). K. Bauch 'Zum
 Werk des Jan Lievens (II)' *Pantheon* 25 (1967) 160ff argues that Lievens fol-
 lowed Rembrandt. W. Stechow 'Rembrandt's representations of the raising of
 Lazarus' *Los Angeles County Museum of Art Bulletin* 19 (1973) 7–11 suggests
 plausibly that we 'be satisfied with the thought of mutual inspiration.'
5 Stechow 'Rembrandt's representations of the raising of Lazarus' 9
6 Ibid 8

CHAPTER 4

1 Matthew Henry *An Exposition of the Old and New Testament* (London nd)
 4th ed IV (Luke 15)
2 Ibid
3 *Melanchthon on Christian Doctrine: Loci Communes 1555* trans Clyde Mans-
 chreck (New York 1965) 60
4 *Commentary on a Harmony* II 344–8
5 Ibid II 347
6 Ibid II 347–8
7 *The Penitent Pardoned: or a Discourse of the Nature of Sin and the Efficacy of
 Repentance under the Parable of the Prodigal Son* (London 1676) 2
8 *Annotations upon All the Books of the Old and New Testaments* 3rd ed (London
 1657)
9 *Rembrandt: Life and Work* 3rd ed 234. Also typical is Hans-Martin Rotermund's
 reading of the picture as a personal religious statement, Rembrandt's 'last
 word,' expressed in the year before his death, in which he 'achieved a synthesis of
 his own life situation and the biblical story he was portraying. Rembrandt
 here embraced the center of the Gospel: the return home of one who has been
 lost;' *Rembrandt's Drawings and Etchings for the Bible* trans Shierry M.

Weber (Philadelphia 1969) 185. The personal force of the painting is, of course, indisputable, though there is a crudeness to be resisted in explaining a great artistic creation in terms of the artist's life experience. (Other Rembrandt students, too, need introducing to T.S. Eliot's well-known demand that we distinguish between 'the man who suffers' and 'the mind which creates.') Also deserving resistance from the standpoint of the present study, and again not untypical, is Rotermund's isolation of Rembrandt from his historical setting in Protestant Holland, gifting him with a special personal insight into the 'center of the Gospel.' That centre, it must be insisted, is one that Rotermund and other modern Protestant commentators on Rembrandt suppose themselves able to recognize because they, like the artist himself, have accepted Reformation direction in looking for it. It may be dead centre, the very essence of biblical truth – one can hardly insist to devout Rembrandtists that it is not – but it is also the Reformation's way of seeing.

10 Christian Tümpel 'Studien zur Ikonographie der Historien Rembrandts, Deutung und Interpretation der Bildinhalte' *Nederlands Kunsthistorisch Jaarboek* 20 (1969) 133–4

11 See Jan Bialostocki's argument that the late Rembrandt's real interest was invested in 'encompassing themes' (in this case the Reformation master theme of forgiveness or mercy) not in precise definition of subject matter; 'Ikonographische Forschungen zu Rembrandts Werk' *Münchner Jahrbuch der bildenden Kunst* 3 (1957) 195–210, rpt in *Stil und Ikonographie, Studien zur Kunstwissenschaft* (Dresden 1966) 126–55.

CHAPTER 5

1 Such painters were not necessarily avowed Protestants. At least eight versions of John Preaching were painted by Catholic Abraham Bloemaert in Catholic Utrecht.

2 *Luther's Works* LI Sermons 1 165

3 'Preface [to the New Testament]' *The Reformation Writings of Martin Luther* II *The Spirit of the Protestant Reformation* ed and trans Bertram Lee Woolf (London 1956) 283

4 Jacobus Kimedoncius *Of the Redemption of Mankind* trans Hugh Ince (London 1598) 51

5 *Institutes of the Christian Religion* 4.17.39 ed John T. McNeill and trans Ford Lewis Battles (Philadelphia 1960)

6 Ibid. 4.1.1.

7 'Reply to Sadoleto' *John Calvin and Jacopo Sadoleto: A Reformation Debate* ed John C. Olin (New York 1966) 74

8 *Luther's Works* LI Sermons 1 373

9 *Luther's Works* XXXI *Career of the Reformer* I ed Harold J. Grimm (Philadelphia 1957) 357
10 W.A. Visser 't Hooft *Rembrandt and the Gospel* (London 1957) 28
11 Peter Geyl *The Revolt of the Netherlands, 1555–1609* (London 1932) 91
12 *History of the Reformation in the Low Countries* (London 1720–23) I 172.
The importance that Protestants gave to the Psalms is widely reflected in poetry, and religious poets saw themselves as followers of David, 'the Psalmist.' The Psalms were held in veneration as the book of the Old Testament that most clearly anticipated the promise of divine love and redemption in the New. There is 'no other book,' said Calvin, 'in which there is recorded so many deliverances,' nor any that gave such prominence to 'the evidences and experiences of the fatherly providence and solicitude which God exercises towards us;' 'The Author's Preface' *Commentary on the Book of Psalms* I trans James Anderson (Edinburgh 1845; rpt Grand Rapids 1949) xxxviii. God's providence and solicitude are shown in the Psalms, characteristically, in images of blessedness and reconciliation in nature, in God's transformation of nature's ordinary functions and appearances into vehicles of his benevolence: 'Blessed is the man who thou choosest ... Thou visitest the earth, and waterest it: thou greatly enrichest it with the river of God, which is full of water: thou preparest them corn, when thou hast so provided for it. Thou waterest the ridges thereof abundantly: thou settlest the furrows thereof. Thou makest it soft with showers.' (Psalm 65:4–10) In the most famous of all the Psalms: 'he maketh me to lie down in green pastures: he leadeth me beside the still waters. He restoreth my soul ...' (Psalm 23:2–3) More examples would show more fully that there is an intense consciousness of landscape throughout the Psalms. It is worth at least a question in passing whether Northern landscape artists, unavoidably familiar with this sacred poetry and song, do not derive a motif from it.
13 *The Revolt of the Netherlands* 91
14 Kenneth Clark *Rembrandt and the Italian Renaissance* (New York 1966) 185

CHAPTER 6

1 Neil MacLaren *The Dutch School* (London 1960) 230
2 *Commentary on a Harmony of the Evangelists* II trans William Pringle (Edinburgh 1845) 390
3 C.O. Kibish 'Lucas Cranach's *Christ Blessing the Children*, a problem of Lutheran iconography' *Art Bulletin* 37 (1955) 196–203; for Cranach's connection with the Reformation, see also H. von Hintzenstern *Lucas Cranach d. A. Altarbilder aus der Reformationszeit* (Berlin 1972).

4 Rose Wishnevsky *Studien zum 'Portrait Historié' in den Niederlanden* (Munich 1967)

5 See Seymour Slive 'Notes on the relationship of Protestantism to seventeenth-century Dutch painting' *Art Quarterly* 19 (1956) 9.

6 *The Religious and Historical Paintings of Jan Steen* (Oxford 1977) 61. Although Kirschenbaum's account of the characteristics of Protestant painting ignores the essential idea of grace, he gives useful emphasis to Steen's Protestant-like interest in the Bible as a source for visual narratives (as distinct from sacred images) and to his avoidance of such traditional Catholic subjects as saints, martyrdoms, sacred conversations, and scenes from the passion.

7 *Commentary on a Harmony* II 389–390

8 *Luther's Works* LI *Sermons* I ed and trans John W. Doberstein (Philadelphia 1969) 172.

9 Ibid 192

10 See above, note 12 to Chapter 5.

11 In an article on the newly discovered Rembrandt painting of *The Baptism of the Eunuch* now in the Aartsbisschoppelijk Rijksumuseum of Utrecht, H.L.M. Defoer comments on the 'unprecedented popularity' of the subject from the beginning of the seventeenth-century and makes the point that this new interest 'must be linked with the establishment of the Reformation in the North;' 'Rembrandt van Rijn, De Doop van de Kammerling' *Oud Holland* 91 (1977) 26.

12 Hans-Martin Rotermund *Rembrandt's Drawings and Etchings For the Bible* trans Shierry M. Weber (Philadelphia and Boston 1969) 18

13 Paul's lead was of course followed in Reformation sermons and commentaries. Typically, Calvin remarks Paul's shift from 'general election' to 'another and peculiar election.' Whereas Moses had seen God choosing 'the whole seed of Jacob without exception,' the point Paul derives from Genesis 25, and what Calvin would have his own followers understand, is that God distinguishes according to 'his own good pleasure' and 'may choose whom he will as heirs to eternal salvation;' *Commentaries on the First Book of Moses Called Genesis* II trans John King (Edinburgh 1850; rpt Grand Rapids 1949) 47.

14 A comparison of these two paintings has been made by Wolfgang Stechow, who notes the quietness and concentration of Rembrandt's version, but does not attempt to explain its qualities in terms of the Reformation background; 'Jacob blessing the sons of Joseph, from early Christian times to Rembrandt' *Gazette des Beaux-Arts* ser 6 23 (1943) 193–208.

15 The Book of Tobit and other books of the Apocrypha were certainly not inaccessible or hard to find. They were not, however, recommended Protestant reading: 'Much Protestant (especially Calvinist) opinion disapproved of the Apocrypha, which are frequently absent from extant copies of the Geneva

Bible, particularly those printed in Holland;' *Cambridge History of the Bible* III (Cambridge 1963) 169.

16 The differences between the two versions are well described by Rosenberg *Rembrandt: Life and Work* 3rd ed (New York 1968) 175–6.

17 *Confessions* trans E.B. Pusey (London nd) 207

CHAPTER 7

1 *The Sermons of John Donne* ed Evelyn M. Simpson and George R. Potter (Berkeley and Los Angeles 1952–63) I 140

2 Réau *Iconographie de l'art Chrétien* III 1038

3 *Commentary upon the Acts of the Apostles* I trans Christopher Fetherstone (1585) and ed Henry Beveridge (Edinburgh 1845) 372

4 Aelbert Cuyp – whose *Conversion of Paul* is as heroicly excited as any – was an unusually well-accredited Protestant, one of the few Protestant painters who is known to have taken on parish duties. He became a deacon of the Dutch Reformed community in Dordrecht in 1660, 'Holy Ghost Master' of the pesthouse of the Groote Kerk in 1675–6, and a member of the 'High Court' during the years 1680–82; Hofstede de Groot *A Catalogue Raisonné of the Works of the Most Eminent Dutch Painters* II tr and ed Edward G. Hawke (London 1909) 2.

5 Calvin – perhaps influenced by the tradition in art – also imagines Paul with a horse: his falling to the ground 'was the first beginning of the bringing down of Paul that he might become apt to hear the voice of Christ, which he had despised so long as he sat upon his horse;' *Commentary upon Acts* I 369.

6 Réau *Iconographie de l'art Chrétien* III 1038

7 J.B. Broadbent *Some Graver Subject* (London 1960) 287

8 Cf Walter Friedlaender *Caravaggio Studies* (Princeton 1955) 9.

9 But see Munz's suggestion that the etching known as 'A Cavalry Fight' (B 117/1) may be a Conversion of Paul; *Rembrandt's Etchings* (London 1952). Benesch includes a 'Conversion of Saul' (Benesch C103) among copies after unknown originals and suggests that 'this is a replica of a lost drawing by Rembrandt which must have originated about 1659–60.'

10 I have adopted Tümpel's title for this drawing as well as his identification of the subject. Tümpel suggests that Rembrandt took his figure of a fairly young Paul from an imitator of Michelangelo's painting, not from Michelangelo directly; *Rembrandt legt die Bibel aus, Zeichnungen und Radierungen aus dem Kupferstichkabinett der Staatlichen Museen Preussischer Kulturbesitz Berlin* (1970) 123.

11 *Rembrandt and the Italian Renaissance* (New York 1966) 92

12 Visser 't Hooft *Rembrandt and the Gospel* (London 1957) 24

13 'Worldly and Religious Portraits in Rembrandt's Late Art' *Art Quarterly* 19 (1956) 338

CHAPTER 8

1 Jean Leymarie *Dutch Painting* (Geneva 1956) 133
2 Léon Wencelius, for example, says of the portraits that they are 'marqués par la mort à venir;' *Rembrandt et Calvin* (Paris 1937) 37.
3 *Paradise Lost* III 212
4 Stephen Jay Gould *The Panda's Thumb: More Reflections on Natural History* (New York 1980) 98–103; Konrad Lorenz *Studies in Animal and Human Behavior* II (Cambridge Mass. 1971) 115–95.

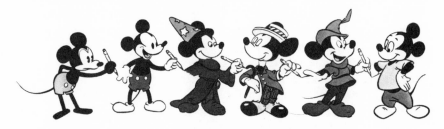

The Evolution of Mickey Mouse © Walt Disney Productions

5 Visser 't Hooft *Rembrandt and the Gospel* 24
6 Eric Newton and William Neil *Two Thousand Years of Christian Art* (New York 1966) 199
7 White (*Rembrandt as an Etcher* I 76) argues that Rembrandt's source is Luke, on the ground that only the third gospel mentions a good and bad thief and that Rembrandt has distinguished between the two by placing the good thief in the light (to the right) and the bad one in the shadow (to the left). This is not immediately convincing. The figures seem about equally in and out of light and shadow, and if the figure on the right is distinguished in any way it is perhaps for suffering the most agonizing crucifixion of the three. I would guess that Rembrandt was satisfied to suppose he was dealing with a gospel story without taking much trouble to decide which gospel. One might also guess, however, that if Rembrandt did in fact choose one version and reject others, he would have been most strongly drawn to Matthew's stronger drama. Luke omits the earthquake, and his account of the centurion's conversion speech ('certainly this was a righteous man') would do less to stir a Protestant imagination than Matthew's 'Truly this was the Son of God.'
8 In an essay on the modern Dutch painter and sculptor Henk Krijger that has

come late to hand, Gerard Rothuizen compares Krijger's little figures with Rembrandt's and suggests that the *mannetjes*, or little men, of both artists are men turned into children through a perspective dominated by *misericordia*; *De oude Man van Hoy: Figuren en Landschappen* (Kampen 1971) 10.

9 Visser 't Hooft *Rembrandt and the Gospel* 115–6

10 Ibid

11 Ibid. In more recent work, Hans-Martin Rotermund has renewed this emphasis on Rembrandt's personal reading of the Bible; *Rembrandt's Drawings and Etchings for the Bible* trans Shierry M. Weber (Philadelphia and Boston 1969). A strong antidote to this kind of piety in Rembrandt studies has come from (still another cleric) Christian Tümpel in his 'Studien zur Ikonographie der Historien Rembrandts, Deutung und Interpretation der Bildinhalte,' *Nederlands Kunsthistorisch Jaarboek* 20 (1969) 107–98. Tümpel argues that Rembrandt was heavily dependent upon iconographic tradition, that he 'did not start from the text of the Bible,' and that he 'possessed representations of every subject he treated' (108–9). Neither view of Rembrandt – the pious reader of his Bible or the careful follower of pictorial tradition – is inescapably at odds with the bias of the present study. That is, Rembrandt may have read his Bible with great piety and attention and still have read it in essentially Reformation ways; he may, on the other hand, have worked very knowledgeably within a tradition of Biblical illustration (the evidence is overwhelming that he did) and still have brought his own Reformation-influenced understanding to subjects and motifs already thoroughly worked out by other artists.

12 Visser 't Hooft *Rembrandt and the Gospel* 30

13 Ibid

14 Ibid 29

15 These detractions are perhaps not wholly deserved, but neither, given the essential opposition between an historical perspective and a devout one, are they easily avoided. Visser 't Hooft was an eminent clergyman addressing himself, evidently, to devout readers and using Rembrandt to illustrate a work that is almost a religious tract. Thus he could permit himself to say that 'in the year of his death it became terribly apparent that Rembrandt had failed in the struggle for existence, but also that he found strength and comfort in the gospel even in – or perhaps rather through his need ... He could depart in peace for his eyes had seen salvation.' (17) He rejects a Roman Catholic critic's welcome of 'Rembrandt's message' as an 'elucidation of one part of the gospel' on the ground that what Rembrandt saw and painted was not one part only, but 'the very *centre* of the Revelation.' (128) The Bible revealed itself to Rembrandt 'as the eternal truth; he listened to it, and he interpreted it. This inner development contributed to the creation of a personal style appropriate to the biblical language.' (111) Rembrandt was 'a biblical artist, and thus a true master of exegesis.' (59) As such,

he found it necessary to abandon the baroque: 'There came a time when he discovered how impossible it was to represent in this way what he found in the Bible. He broke free from the pressure of the Zeitgeist and created a personal style of his own.' (114–5) What I am opposing to this view is, of course, the notion that Rembrandt's style, personal as it is, is very much in harmony with a Zeitgeist – that he is, in short, a Reformation artist.

16 Wencelius was surely right to insist that Rembrandt's religion was not 'super-confessional' but Calvinist (*Rembrandt et Calvin* 138). Unfortunately, it has been easy for later students to complain that Wencelius 'goes too far in stress-ing the identity of the religious concepts of Rembrandt and Calvin' (Rosenberg 354 n11) and dismiss an emphasis that deserves keeping. Clearly, there is exag-geration in the claim that Rembrandt's paintings and etchings show his attach-ment to such Calvinist doctrines as special vocation and predestination – 'chez l'artiste, comme chez le théologien' – and certain other features of the Calvinism defined by Wencelius belong equally to other branches of the Reformation and to Christianity in general. It is, nevertheless, useful to have Rembrandt's religion identified as belonging to an historical – Reformation – type, which in seventeenth-century Amsterdam almost inescapably meant Calvinist. It would have been natural for Rembrandt to have had deeply internalized Calvinist notions concerning man, God, and grace – perhaps impossible to avoid them, even as an indifferent church-goer. It seems equally mistaken then to imagine Rembrandt as a theological free-lance or to assign him, as Rosenberg and others have done, to Mennonism, a Reformation minority sect inevitably doctrinaire and zealous in the small points by which it set itself apart from the larger Reformation movements.

17 See Kenneth Clark's discussion of this figure as an example of the power of Rembrandt's allusions to Quattrocento primitivism and his use of profile for 'the feelings of magical remoteness;' *Rembrandt and the Italian Renaissance* (New York 1966) 168–70.

18 Ibid 170

19 John Calvin *Commentary on the Gospel According to John* I trans William Pringle (Edinburgh 1847) 205–6 and 45

20 See White for an alternative interpretation of this etching: the changes in the fourth state constitute a change of subject matter and go back to the moment when Christ, in human despair, cries out 'My God, My God, why hast thou forsaken me?' The obscure horseman is the centurion before his conversion. The altered figure of Christ expresses the despair of a still living person (*Rembrandt as an Etcher* 100–103).

21 *Confessions* trans E.B. Pusey (London nd) 166

22 Kenneth Clark *An Introduction to Rembrandt* (London 1978)

Index

Anabaptists 66, 78
Aertsen, Peter 36–8
Anti-humanism 9–11, 111, 113
Aristotle 9–10
Aquinas, St Thomas 25
Augustine, St 6, 8, 9, 12, 24, 25, 29, 41, 43, 105, 108, 134–5

Bacon, Francis 19
Bastingius, Jeremiah 25
Beatrizet, N. 116
Benedetto da Mantova 12
Benesch, Otto 116–17
Bol, Hans 53
Brandt, Gerard 69–70
Brentius, Joannes 66
Brueghel, Jan, the Elder 71
Brueghel, Peter 68, 70
Bunyan, John 24
Burckhardt, Jacob 124

Calvin, John 4, 6, 24, 25, 29, 52–3, 66, 71, 78, 108–9
Caravaggio, Michelangelo Merisi da 4, 26–9, 32, 113–15
Castiglione, Baldassare 11
Clark, Kenneth, Lord 61, 75, 116, 132, 136

Collaert, J. 72–5
Colonna, Vittoria 12
Cornelis Cornelisz 82–3
Cranach, Lucas 4, 36–7, 80
Cuyp, Aelbert 111
Cuyp, Benjamin Gerritz. 110

Decimal Index of the Art of the Low Countries 52, 67
Donne, John 6, 108, 127
Dowsing, William 4
Dürer, Albrecht 4, 11, 19

Erasmus 4, 36, 136

Francken, Hieronymus 81–2
Friedlaender, Walter 27

Galle, Philip 57–61
Giotto 45
Goodman, John 53
Gould, Stephen Jay 125
Goyen, Jan van 86
Grace, Protestant doctrine of 5–19, 24–5
Grotius, Hugo 53
Guercino, G.F. 99–101

Hals, Franz 86
Hans von Aachen 89, 91
Heemskerck, Maerten van 53–61, 95–7, 110
Hemessen, Jan Sanders van 22–6, 29, 30
Herbert, George 127
Holbein the Younger, Hans 4
Hollanda, Francesco 12
Hoogstraten, Samuel van 78, 80
Humanism of Renaissance art 9–11; *see also* Anti-humanism
Huygens, Constantine 85

Iconoclasm 4

Jordaens, Jacob 82, 86–8, 90–4

Kimedoncius, Jacob 66
Kirschenbaum, Baruch D. 86

Lastman, Peter 45, 56, 95
Leonardo da Vinci 11
Lievens, Jan 43–8, 85
Lorenz, Konrad 125
Loyola, St Ignatius 27
Lucas van Leyden 109
Luther, Martin 5, 7–11, 25, 29, 36, 41, 43, 66–7, 80, 89, 94, 130, 133

Maes, Nicolaes 78–9
Mâle, Emile 5
Mander, Karel van 89
Massys, Cornelis 55
Massys, Jan 86
Massys, Quinten 86
Melanchthon, Philipp 52
Michelangelo 4, 11–19, 115–17, 124, 126
Milton, John 111, 120, 125
Moded, Herman 69

Moeyart, Nicolaes 33
Mouse, Mickey 125

Neri, St Filippo 27
Noort, Adam van 83–5

Ochino, Bernardino 12
Oost, Jacob van 29–32

Paul, St 6–10, 24, 108–20
Pisanello, Antonio 132
Pole, Reginald Cardinal 12
Portrait historié 80–1
Psalms, Book of 89, 144n12
Pynas, Jan 32, 39–41, 95

Réau, Louis 113
Rembrandt: *The Apostle Paul at His Desk* 118–20; *The Apostle Peter Denying Christ* 134; *Baptism of the Ethiopian Eunuch* 94–7; *Christ and the Woman Taken in Adultery* 97; *Christ Preaching the Remission of Sins* 71–5; *Conversion of Paul* 115–16; *David Playing the Harp Before Saul* 135–6; *Departure of Tobias* 61–2; *Entombment of Christ* 116; 'Hundred Guilder Print' 88, 94, 97, 126–7; *Isaac Blessing Jacob* 97–8; *Jacob Blessing the Children of Joseph* 98–101; *Jacob Wrestling with the Angel* 101–2; *Peter and John Healing the Cripple* 96–7; *Raguel Welcoming Tobias* 101; *Raising of Lazarus* (4 presentations) 42–8; *Reconciliation of David and Absalom* 100–1; *Return of the Prodigal Son* (2 presentations) 55, 60–3; *Sacrifice of Abraham* (2 presentations) 102–5; *Sacrifice of*

Manoah 101; *Self-Portrait as the Apostle Paul* 117–20; *The Three Crosses* (2 presentations) 128–36
Rosenberg, Jacob 61
Rubens, Peter Paul 45, 86, 127

Sadoleto, Jacopo 66
Sandrart, Jaochim van 28–9
Schiller, Gertrud 36
Sellaert, Vincent 81, 84
Stalbent, Adriaen van 68
Stechow, Wolfgang 43

Tolnay, Charles de 11–20

Uden, Lucas van 89–92

Valckert, Werner van den 81–3
Valdés, Juan 12
Van Dyck, Anthony 80
Vasari, Giorgio 13
Velde, E. van de 69, 86
Vermeer, Jan 86
Veronese, Paolo 86
Vinckeboons, David 89–90, 92
Visser 't Hooft, W.A. 126, 130–1, 148n15
Vos, Marten de 37–9, 40, 43, 72–5

Wencelius, Léon 149n16
Wet, Jacob de 78, 81

Zuccari, Federigo 28
Zwingli, Ulrich 4

This book
was designed by
WILLIAM RUETER
and was printed by
University of
Toronto
Press